The Complete Book
of Calligraphy

D0034065

Emma Macalik Butterworth

The Complete Book of Calligraphy

THORSONS PUBLISHING GROUP

First published in the United Kingdom 1981

British Library Cataloguing in Publication Data

Butterworth, Emma Macalik
The complete book of calligraphy.
1. Calligraphy
I. Title
745.6'1 NK3600

ISBN 0-7225-0794-1
ISBN 0-7225-0704-6 pbk

*Published by Thorsons Publishers Limited,
Wellingborough, Northamptonshire, NN8 2RQ, England*

Printed in Great Britain by
Butler & Tanner Ltd, Frome and London

9 11 13 15 14 12 10

Contents

With gratitude
to
my husband,
who encouraged me

List of Plates

Foreword

Calligraphy is the art of fine writing. Its beginnings go back beyond recorded time to the first person who scratched a pictograph on the walls of a cave.

Writing is communication by means of established symbols. Prehistoric picture drawings gave birth to hieroglyphics (circa 3000 B.C.) and then to the Greek alphabet. By 200 B.C., the Roman alphabet of twenty-three characters (identical to our present alphabet of "capital characters," except that *U, J,* and *W* were missing) had been perfected. What we now call lower-case letters, and which are properly known as minuscules, were devised from various scripts under the auspices of Charlemagne and his minister, Alcuin, in the ninth century.

Literacy in those times was rare, and scribes (those who enscribed) were valued and essential members of the hierarchy. Roman scribes held formal rank and were permitted to propose laws. Irish law prescribed the same punishment for the murder of a scribe as it did for the murder of a bishop or king. Yet what these men wrote was simply a basic hand, practical and legible but without beauty.

With the advent of the calligrapher, writing was raised to the status of an art. The characters acquired beauty and grace to augment legibility. Calligraphers, rather than ordinary scribes, recorded the writings of kings and popes. During the Dark Ages, much of the writing was done by monks and priests laboring in church and monastic libraries. Their work was by no means entirely religious in nature, however, and it is fair to say that what knowledge has come down to us from the Dark Ages was preserved by those who spent their lives preparing manuscripts (*manu*—the Latin word for hand; *script*—the Latin word for writing). Many of these ancient manuscripts, embossed in gold and inlaid with precious stones, were spared by

illiterate barbarians because of their intrinsic worth, thus preserving for mankind historical and philosophical tracts that otherwise would have been lost.

Today we see a revival of this ancient art. In a modern world of complicated machinery, calligraphy offers the warmth and pride of individual craftsmanship. Calligraphers are in demand by civic and religious organizations, government, business and professional groups, and individuals who appreciate original and finely executed documents and lettering.

The beginning calligrapher learns discipline and grows in self-confidence as he or she acquires skill. The art of calligraphy will not only give you the personal satisfaction of creating something fine; it will also give pleasure to all who see it over the many years it will endure.

Emma Macalik Butterworth

Publisher's Note

This book was written and originally published in the United States of America, and consequently the author makes reference to brands of calligraphic materials which are readily available in that country.

It is realized that some of the brand names mentioned in the book are unfamiliar to suppliers in the United Kingdom, but research indicates that equivalent materials are obtainable without difficulty from art shops, stationery stores and drawing office suppliers.

The calligraphic pen holder referred to on page 77, for instance, is not easy to obtain in this country but specially shaped and inexpensive plastic holders can be found in art shops. Also, a suitable substitute for Adhezo-tack, a product referred to a number of times in the book, is Blu-Tack, made by Bostik Ltd. and available in most stationery shops, while the nearest equivalent to Testor's Pla Enamel is Humbrol which can be bought from any model shop.

Should any difficulty be found in obtaining the types of paper mentioned, we suggest that readers write or visit Falkiner Fine Papers Ltd. of 4 Mart Street, London WC2E 8DE, who have a very wide range in stock.

1
The Nylon Tip Pen

Part One
Basic Calligraphic Strokes

Materials

Several black, fine-point, nylon tip pens (Flair, Parker, or equivalent)
Loose-leaf notebook paper with $5/16$-inch lines
One standard letter-size file folder

While calligraphy is a form of writing and perfectly suitable for normal correspondence, it is different from the handwriting (usually called "cursive") taught in elementary school.

Calligraphy is basically the mastery of certain pen strokes which, although they appear at first glance to be simple, are actually a challenge to learn. But it is a matter of patient practice rather than an endeavor that strictly requires natural skill or artistic talent. Calligraphy can be accomplished by virtually anyone wishing to take the time to learn it. However, this caveat must be added: Because of the way calligraphic letters are formed, it is nearly impossible to teach left-handers calligraphic writing. Nevertheless, a left-handed student who is able to develop his or her own technique (which would be tantamount to learning how to write all over again) may become a calligrapher, and left-handed pens are available.

In mastering the basic strokes, and for some time in our study of calligraphy beyond the basic strokes, we will be using a common, fine-point, nylon tip pen, such as Flair or Parker. Nylon tip pens of this quality provide the advantage of a smooth stroke that helps the learning process. Cheaper nylon tip pens tend to lose their fine point quickly. Ballpoint pens are unsuitable and must *not* be used.

Standard lined notebook paper is perfect for practicing basic calligraphy. Its ruled lines (usually ⁵/₁₆ inch apart) are precisely the correct width for practicing the exercises. (The same width is used in the illustrations throughout most of this book.) The paper is translucent, so that the illustrated exercises can be traced exactly the same size as they later will be drawn without tracing. And finally, it is inexpensive. For this reason it may be used freely. Use only one side of the sheet.

The Calligrapher's Posture

The first step is to learn the correct sitting position. Put all the materials before you on the table or desk. Turn your chair to the *left* so that you are sitting at about a 30-degree angle to the writing surface, with your entire body facing toward the left.

If you have a student desk with chair and writing surface in a fixed position, slip into the chair normally and then turn yourself at a 30-degree angle to the writing surface. Sit with your back fairly straight; never slouch over your work. An improper position is uncomfortable and tiring, muscles are under undue strain, and breathing may even be restricted. If you are sitting correctly, your eyes will be at the most suitable distance from your work: never closer than ten inches from the paper. The way you sit determines how well you will be able to form the strokes of calligraphic letters.

Place your feet in any comfortable position. You may prop your *left* foot on the rung of the chair or on a box. When you feel yourself becoming tense, stop. Get up, walk around a little, and, before resuming work, wash your hands. Cold water relaxes the muscles in your hand. Your best calligraphy will be done while you are relaxed.

Good lighting is very important. Indirect daylight coming from the left side is best. (Direct sunlight causes a glare on the paper.) At night use a lamp with a 60- or 100-watt bulb. Place the lamp so the light comes over your *left* shoulder to reduce the amount of shadow cast on your work.

When you have seated yourself comfortably and correctly under proper lighting, place a stack of about ten lined notebook sheets in front of you and tilt them toward the *left,* so that you and your paper are facing the *same way,* at the *same angle.*

Hold the nylon tip pen as you would normally hold a pencil:

lightly, between your thumb and index finger, with the lower part of the pen resting on the middle finger for support. In calligraphic writing the wrist and hand do not control the pen point. *All control movement comes from the arm.* In fact, even your fingers should be stationary. Write a few lines in your normal handwriting; you will see that your fingers move around quite vigorously and that much movement is coming from your wrist. In calligraphy, imagine that your pen, fingers, hand, wrist, and forearm form *one rigid unit,* without a joint or hinge. In other words, visualize your wrist as being in a cast so that you cannot bend it.

Pen-point movement comes from the shoulder and the elbow. Writing occurs as the forearm (moved by the elbow and shoulder) directs the pen across the page, forming strokes.

Practice Techniques

In ordinary cursive writing, the arm and hand are free to move any distance across the paper. In calligraphy, the forearm is limited in its movement across the page to a span of about five inches; any greater movement leads to a distortion of the calligraphic letters (or of the strokes). Therefore, when it is necessary to exceed this limited span, move the *paper* back and forth instead of the hand. Similarly, when moving from one line to the next down the page, the *paper* is moved up; the writing hand is not moved down. Use your free (left) hand, which will normally be resting lightly on the writing surface, to move the paper.

Some awkwardness is to be expected at first, and you will not have as much control over pen strokes as you would like. After only a little practice, however, you will be surprised at how well you are doing. After just a few practice sessions, you will realize that the calligraphic position and arm movements are actually less tiring than the hand-wrist movements of cursive writing.

As you begin the following exercises (and throughout the book) remember that no two people can, or will, acquire the skill of calligraphy at the same speed. Keep practicing until your work is (almost) identical to the illustration. Never omit an exercise.

Clean hands are important and make calligraphy just a little easier. Wash your hands before starting and frequently while practicing. Remove any jewelry (including your watch) that might get in your way or distract you.

Practice at least twenty minutes every day. Practice and concentration help build the discipline that will be needed later when things become more difficult.

While daily practice is important, it is equally important not to force yourself to keep on working when tired. Nothing comes to the tired calligrapher except frustration.

Follow this working method:

- *Study* each new exercise.
- *Trace* the strokes and letters to acquire understanding and facility of movement.
- *Draw* the strokes (practice without tracing).

This last step is optional. While many students like to draw the strokes freehand to see how well they are progressing, others will find it unsatisfying, especially in the early exercises.

Each exercise builds on skills learned from previous exercises so that more precise control of pen strokes is continually developed. Do not hurry any exercise.

Exercise One

Place a sheet of lined loose-leaf notebook paper over the illustration and trace several lines of the strokes until your hand gets the feel of a free movement. Strokes are made in the directions indicated by the arrows; where the arrows are numbered, the strokes are made in that sequence. Begin at the left margin line on your paper, and skip one space between lines of strokes. The strokes must touch both the upper and lower ruled lines.

Line 1: Trace the strokes, keeping them parallel and slightly slanted (about 5 degrees) toward the right. When making the downward stroke, your nylon tip pen should flow smoothly (with rhythm) across the paper. Note how precisely the strokes are spaced; precise spacing gives beauty to calligraphic writing. After you have complete control over the movement of this stroke, draw the strokes freehand, without tracing.

Line 2: A slightly slanted downward stroke is made. Then a diagonal stroke from the bottom of the first stroke is drawn upward to where the third stroke, another downward stroke parallel to the first one,

begins. Examine the diagram and follow the sequence indicated by the numbered arrows.

Line 3: This repeats the strokes in Line 2 except that the strokes are joined and drawn continuously. When tracing this line, be swift, and you will get the *feel* that will permit you to keep all the strokes an equal distance apart.

Line 4: This line repeats Line 3, to which a second line of the strokes is added. First, complete one line of strokes, then repeat the strokes on the next ruled line. Concentrate on having the strokes on both lines nearly touching one another.

Some of the strokes in Exercise One are very much like these hieroglyphics of 5000 B.C.

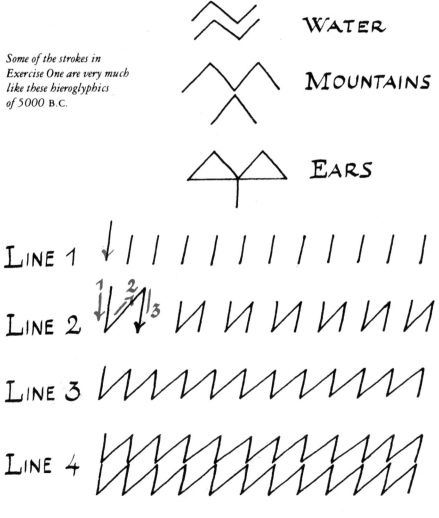

WATER

MOUNTAINS

EARS

LINE 1

LINE 2

LINE 3

LINE 4

Line 5: The strokes here are all diagonal. Follow the sequence indicated by the arrows. Remember the *study, trace,* and *draw* procedure. After a few lines of practice, filling in alternate sections as shown in the next line will help you to see how well your strokes are proportioned.

Lines 6 and 7: These are continuations of Line 5. Draw them with swift strokes and strive for uniformity.

Practice all lines daily, drawing three or four lines of each, and more if any particular line is especially difficult.

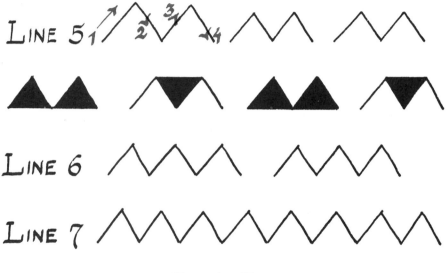

Exercise Two

Line 1: Make downward Stroke 1. Lift pen, then make Stroke 2 by drawing an arch from the center point of Stroke 1 to the top of the line, and then downward, paralleling Stroke 1. A good deal of tracing may be necessary before you feel the rhythmic flow of the connected shapes.

Lines 2, 3, and 4: All curved strokes must be connected to the previous downward strokes at the same point. Mastering the formation of precise, identical strokes is difficult. Take your time, relax, and don't hold the pen too tightly.

Line 2 *m m m m m m*

Line 3 *mm mm mm m*

Line 4 *mmmmmmmmmm*

Exercise Three

Lines 1, 2, 3, and 4: The curved stroke learned in Exercise Two is inverted so that Stroke 1 ends in an inverted arch curving upward from the bottom to the center of the space between the lines. The pen is then lifted so that downward Stroke 2 can be made. Concentrate on the downward strokes and slant them toward the right, keeping them parallel. Make sure that the strokes touch both ruled lines.

Line 5: Line 5 combines Line 1 of Exercise Two with Line 1 of this exercise.

Line 1 *U U U U U U U*

Line 2 *U U U U U U*

Line 3 *U U U U*

Line 4 *UUUUUUUUU*

Line 5 *U n U n U n U n U*

Exercise Four

The nylon tip pen does not permit the fine- and broad-line calligraphic strokes possible with the nib pen in drawing the *o*, for example. But learning the correct strokes at this point, using the nylon tip pen, will train the mind and hand to use the nib pen correctly later on.

The calligraphic letter *o* is *oval,* not round.

Line 1: The *o* is formed by two curved, downward strokes. Stroke 1 begins just below the ruled line at the top and curves upward at the bottom. Stroke 2 begins by completing the upper curve and ends by joining Stroke 1 toward the bottom. Like the downward strokes previously learned, the *o* has a 5-degree slant to the right.

Line 2: This combines practice of the oval *o* with the downward strokes of Exercise One, in order to provide practice in keeping both figures parallel and properly slanted.

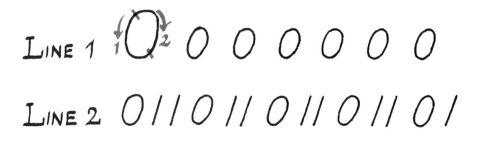

Exercise Five

Line 1: This line provides practice in making parallel downward and horizontal strokes. Slant the downward strokes 1, 2, and 3 slightly toward the right. Stroke 4 is made on the top ruled line, Stroke 5 is in the center of the space, and Stroke 6 is on the bottom line. After practicing this line as illustrated, create your own patterns by using different formations. (These strokes are also good practice for drawing capital letters.)

Line 2: This line combines the downward and horizontal strokes of Line 1 to make a boxlike shape requiring five strokes. Draw Stroke 3 exactly in the center, and keep Strokes 1 and 5 parallel. Draw the lines in numerical sequence and in the directions indicated by the arrows.

Line 3: This row features strokes that extend *above* the top ruled line. The broken line indicates that the taller parallel lines begin in the center of the space between the ruled lines. The taller strokes cover one full line plus about half of the line above; the shorter strokes do not extend beyond the upper and lower ruled lines.

Line 4: Here, the two downward strokes joined by a diagonal stroke are basically the same as in Line 2, Exercise One, except that Stroke 1 extends above the upper ruled line.

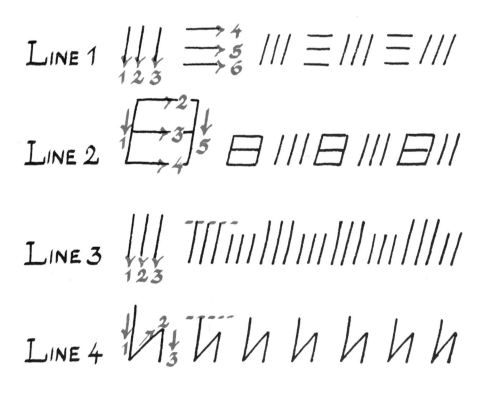

Exercise Six

Line 1: Glide the pen slowly across the page. Practice until the first and second loops are as nearly identical as possible and slant equally to the right. This line must be practiced until it can be performed with a flowing, rhythmic movement.

Line 2: This line continues the loops of Line 1 to provide more practice of this difficult stroke and to help you acquire smoothness and rhythm.

Line 3: This line continues the loops without interruption through a complete span. Try to keep the rhythmic flow without losing control. Lift the pen occasionally to rest and steady your hand.

Line 4: The loops in this line do *not* slant. They are vertical.

Lines 5 and 6: The strokes required here are continuous and progressively more difficult, requiring increasing care to draw them identically.

LINE 1

LINE 2

LINE 3

LINE 4

LINE 5

LINE 6

Exercise Seven

Lines 1, 2, and 3: The figures in Lines 1, 2, and 3 all slant slightly toward the right. The more figures that are joined together (the greater the span), the more difficult it is to maintain uniformity. Notice that the upward and downward strokes cross in the center of the space between the ruled lines.

Line 4: This requires drawing the same basic figure as in Line 1, except that here the figures are upright.

Lines 5 and 6: These lines provide more practice in drawing connected strokes. Again, the greater the span of the connected strokes, the greater the difficulty in maintaining uniformity.

LINE 1

LINE 2

LINE 3

LINE 4

LINE 5

LINE 6

Exercise Eight

The movements of large flowing strokes are designed to develop a greater sense of rhythm. Avoid the temptation to make them quickly, because uncontrolled speed distorts the shape of the stroke. As you acquire more skill, fluency will come naturally.

Line 1: These strokes cover three ruled lines (or two spaces). Note that the loop occupies one full space.

Lines 2 and 3: Here the figures are connected.

Line 4: This row of strokes, larger than most, takes up four ruled lines (or three spaces). Note that the upper and lower loops each take up a full space.

Lines 5 and 6: These lines connect the strokes of Line 4. Trace each line until your pen flows smoothly across the paper. Practice until this drill no longer seems difficult.

Line 7: This row also covers four ruled lines (three spaces). Note again that each loop occupies a full space.

Lines 8 and 9: These lines connect the strokes of Line 7. Practice them until they no longer seem difficult. Lift the pen from time to time to rest.

LINE 1

LINE 2

LINE 3

LINE 4

LINE 5

LINE 6

LINE 7

LINE 8

LINE 9

Part Two

The Alphabet—Lower-Case Letters (Minuscules)

When practicing the exercises in this section, skip only one ruled line between practice lines. This will serve to train your eye and hand to make proper allowances for strokes that go below and above the line.

Continue the working method of *study, trace,* and *draw* throughout each exercise. Practice the lines of each exercise until you are able to make your letters (and words) look nearly identical to the illustrations. The more you practice, the more you will develop good habits.

To give you a better understanding of the fundamental calligraphic principles, the letters are arranged for practice in groups, according to stroke requirements, rather than alphabetically. The enlarged letters with numbered arrows in each exercise show you how to draw each stroke. The semicircles drawn within some letters indicate that you must concentrate on a soft, round stroke.

Before beginning the exercises, a few calligraphic terms are in order. All letters in this section are small letters, or *minuscules.* (They are called *lower-case letters* by printers.) All letters are drawn with reference to two lines: the *base line* (on the bottom) and the *waist line,* which is at the top of such letters as *a, c, e, i, m, n, o, r, s, u, v, w, x,* and *z.* Letters that rise above the waist line *(b, d, f, h, k, l,* and *t)* are called *ascenders;* letters that go below the base line *(g, j, p, q,* and *y)* are called *descenders.* The space between the base and waist lines is one ruled space on the calligrapher's paper.

Exercise One

Line 1: Draw the minuscule *u* between base and waist lines. Drawing the downward stroke between each letter (slanted toward the right) trains your eye for correct formation. In other words, it is just as important for a beginning calligrapher to *arrange* letters evenly apart as it is to *draw* good letters. Draw Stroke 1 with emphasis on the soft curve at the base line, then lift the pen before making Stroke 2. Note that the *u* is drawn taller than it is wide. To get the feel of closely

spaced letters, practice them as illustrated; do not space them farther apart.

Line 2: The letter *l*, which extends above the waist line (indicated by the middle broken line), is an ascender.

Line 3: This line provides practice in drawing the ascender *l* and the *u* uniformly throughout.

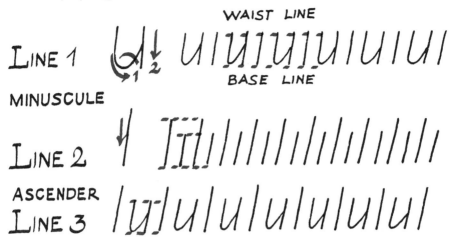

Exercise Two

Line 1: The minuscule *a* is the root for descenders *g* and *q* and for ascender *d*. Once you have learned to draw it correctly, the other letters in this group will be much easier to master.

Line 2: Slant the single strokes slightly toward the right, so that your *a* minuscules will be automatically drawn with a rightward lean, too.

Lines 3 and 4: The descender *q* drops below the base line (the middle dotted line). Before moving to the next line, be sure you have mastered lines 1, 2, 3, and 4.

Line 5: The only difference between descenders *g* and *q* is that descender *g* ends in a soft swing. Concentrate on the downward swing.

Line 6: Remember, space the letters evenly.

Line 7: Note the common basis of *d* and *a*.

Line 8: Make sure that Stroke 2 in ascender *d* is slanted correctly.

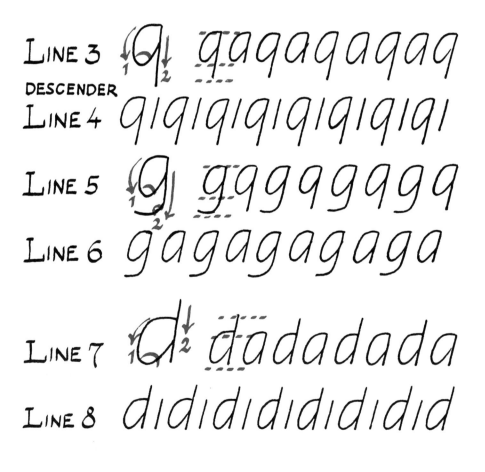

Lines 9 and 10: Four properly formed letters separated by a slanted stroke: your first calligraphic words!

LINE 9 *gladigladigladig*

LINE 10 *quadiquadiquad*

Exercise Three

Line 1: Let your pen swing!

Line 2: Keep the curves in minuscule *c* soft.

Line 3: Another word. The slanted stroke is drawn as a spacer.

Line 4: If your minuscule *c* looks identical to the one illustrated, minuscule *e* will be easier to master. To achieve soft, round, narrow curves, let your pen swing twice in a swift movement.

LINE 1 *cacacacac*

LINE 2 *CICICICICICIC*

LINE 3 *cudicudicudicud*

LINE 4 *ecececece*

Line 5: It is difficult to correctly draw two swings followed by a slanted stroke. Go slowly.

Lines 6 and 7: Practice these words until you have rhythm in your writing.

Line 8: The minuscule *o* with its two swings has the tendency to turn into a round *o* and/or to become pointed at the base and waist lines. A correctly drawn minuscule *o* is oval and rounded at top and bottom. This letter may need more practice than some other minuscules.

Lines 9 and 10: These lines provide good practice in keeping the minuscule *o* oval.

Exercise Four

Line 1: This line has soft curves drawn on the waist line toward the right (instead of on the base line toward the left). Lift your pen

between Stroke 1 and Stroke 2. Visualize an arch when drawing the minuscule *n*. If the page is turned upside down, the minuscule *n* must look like the minuscule *u*.

Lines 2 and 3: When practicing these words, make sure that each minuscule *n* is identical to all the others.

Line 4: The minuscule *m* with its two arches is more difficult to draw than the *n*. Trace until the arches are identical and you have achieved some rhythm.

Lines 5, 6, and 7: Practice these words until they please your eye.

LINE 1 ninininininin

LINE 2 noneinoneinonein

LINE 3 andiandiandiandi

LINE 4 mimimimim

LINE 5 manimanimanim

LINE 6 elmielmielmielmie

LINE 7 moonimoonimoon

Line 8: Draw each ascender *h* exactly as high as the preceding one, concentrating on Stroke 1. Remember the arch.

Lines 9, 10, and 11: Practice until you are drawing the words correctly. Don't cheat yourself!

Line 12: The minuscule *r* has half an arch.

Lines 13, 14, and 15: When writing words containing the minuscule *r*, watch the size of the arch.

LINE 8 ᛁᚦᛝ ᚻnhnhnhnh

LINE 9 henihenihenihenı

LINE 10 helmihelmihelmı

LINE 11 holeiholeiholeihol

LINE 12 ᛁᚦᛝ rnrnrnrnrn

LINE 13 runirunirunirun

LINE 14 ragiragiragirag

LINE 15 roariroariroarir

Exercise Five

Line 1: The ascender *b* is drawn like ascender *h* except that Stroke 2 ends flat on the base line.

Lines 2, 3, and 4: For the minuscule *b*, concentrate on the flat stroke on the base line; the round curve is on the waist line only.

Line 5: Descender *p* has a round curve (arch) on the waist line *and* on the base line. Stroke 2 ends on the upswing, not flat on the base line.

Lines 6 and 7: Practice until you develop a rhythm.

Line 1 bnbnbnbnbn

Line 2 bobibobibobibobi

Line 3 bugibugibugibugi

Line 4 bearibearibearibe

Line 5 pnpnpnpnp

Line 6 popipopipopopip

Line 7 penipenipenipeni

Line 8: Concentrate on the difference between ascender *b* and descender *p.*

LINE 8 *bupibupibupibup*

Exercise Six

Line 1: Draw the dot on the minuscule *i* as high as an ascender.

Lines 2, 3, and 4: Remember the correct formation of slanted downward strokes.

Line 5: The descender *j* is like the minuscule *i*, except that it drops below the base line and ends in a curved swing like the descender *g.*

LINE 1 *iiiiiiiiiiiiiiii*

LINE 2 *iniiiniiiniiiniiiniiinii*

LINE 3 *mileimileimileimile*

LINE 4 *illiilliilliilliilliil*

LINE 5 *jijijijijijiji*

Lines 6, 7, and 8: Pay attention to the descender *p* in *jump*. The word *juggle* is not an easy one; don't rush it. The three descenders with curved swings must be practiced until you can draw them evenly and swiftly.

LINE 6 *jarıjarıjarıjarıj*

LINE 7 *jumpıjumpıjumpı*

LINE 8 *juggleıjuggleıjug*

Exercise Seven

Line 1: The ascender *t* is slanted toward the right, as are the strokes in between. Put the cross-stroke on the waist line.

Lines 2, 3, and 4: Don't draw the cross-stroke on ascender *t* any wider than illustrated. Except in the case of adjacent *t*'s, the cross-stroke is not permitted to touch another letter.

LINE 1 *t*² *ititititititi*

LINE 2 *teamıteamıteamıt*

LINE 3 *joltıjoltıjoltıjoltıjolt*

LINE 4 *matterımatterıma*

Line 5: The letter *f* is called an ascender because in some writing styles it ends on the base line. As the circle indicates, ascender *f* begins in a round curve. The cross-stroke is drawn on the waist line. Stroke 1 of *f,* which here descends below the base line, is the longest stroke in the alphabet. Draw it slowly.

Lines 6, 7, and 8: Try to keep your strokes even!

LINE 5 *ff fififif if if if*

LINE 6 *fitti fitti fitti fitti fi*

LINE 7 *floori floori floor*

LINE 8 *offi offi offi offi o*

Exercise Eight ×

Line 1: The minuscule *s* is a tricky letter. Much tracing will probably be required before you get the feel of the two curves drawn in one stroke. Since there is a tendency to give the *s* a squared-off shape, the oval minuscule *o* is included here as a guide.

Lines 2, 3, and 4: Keep repeating Line 1 if you have trouble with minuscule *s* in these lines.

LINE 1 *sosososososo*

LINE 2 *soapi soapi soapi*

LINE 3 *flossiflossifloss*

LINE 4 *mussedimussedi*

Exercise Nine

Line 1: The oval minuscule *o* should help you to keep your minuscule *x* narrow.

Lines 2, 3, and 4: Keep the letters narrow.

Line 5: Stroke 2 begins just below the center of Stroke 1. Stroke 3 extends slightly farther to the right than Stroke 2.

Line 6: Practice drawing the *k* in conjunction with other letters.

LINE 1 *XOXOXOXOXO*

LINE 2 *foxifoxifoxifoxi*

LINE 3 *maximaximaxim*

LINE 4 *nextinextinextine*

LINE 5 *kikikikikiki*

LINE 6 *kitikitikitikitikiti*

Lines 7 and 8: Remember the arches and the soft, round curves.

LINE 7 *knockıknockıkno*

LINE 8 *jokesıjokesıjoke*

Exercise Ten

The letters in this exercise are drawn slightly slanted toward the right, except minuscules *v, w,* and *x.*

Line 1: The minuscule *v* must form the apex of a perfect inverted triangle.

Lines 2 and 3: Practice spacing.

Line 4: The two *s* minuscules in *vessel* must be identical.

Line 5: The minuscule *w* consists of two *v* minuscules drawn together.

Lines 6, 7, and 8: These words include the minuscules *v* and *x.* Like the minuscule *w,* they are not slanted.

Line 9: Above the base line, descender *y* has the shape of the minuscule *v,* but Stroke 2 begins at the waist line and descends below the base line.

Lines 10, 11, and 12: Make the *v* and the upper portion of the *y* identical in appearance.

LINE 1

Line 2 valveıvalveıvalv

Line 3 vivianıvivianıviv

Line 4 vesselıvesselıve

Line 5 W wıwıwıwı

Line 6 willıwillıwillıwillı

Line 7 waxıwaxıwaxıw

Line 8 reviewıreviewır

Line 9 y yıyıyıyıyıy

Line 10 veryıveryıvery

Line 11 valleyıvalleyıval

Line 12 voyageıvoyageı

Exercise Eleven

Line 1: Learn to make the center stroke of minuscule z in a swift, sure movement.

Lines 2, 3, and 4: Practice the words only after you have mastered the strokes of the minuscule z.

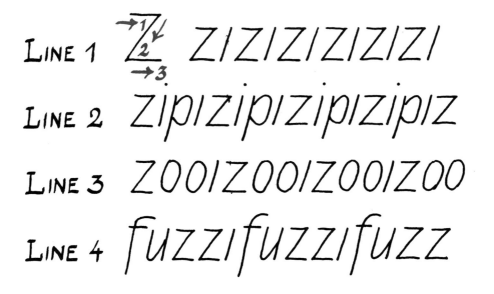

LINE 1 ZIZIZIZIZIZI

LINE 2 ZIPIZIPIZIPIZIPIZ

LINE 3 ZOOIZOOIZOOIZOO

LINE 4 fuzzifuzzifuzz

2
The Italic Nib Fountain Pen

Part One
Basic Calligraphic Strokes

Materials

Italic fountain pen set with B-2 nibs
Lined notebook paper
Dietzgen drawing paper No. 66 (yellow)
Black water-soluble ink
Paper towels
Drawing board
Plastic cushioning material
Jar for storing fountain pen

The nylon tip pen used in the previous exercises produces a line of the same width no matter what the direction of the stroke. Calligraphy entails the use of *fine* and *broad* strokes, which are possible only by using a pen point with a wide tip. A Platignum (or Osmiroid) italic fountain pen, available for the price of a medium-grade fountain pen, is ideal for the exercises in this chapter.

Using a fountain pen instead of a special calligraphic pen, which requires the frequent use of an ink dropper, enables the student to concentrate better on penmanship.

Platignum or Osmiroid italic pen sets are sold with five nibs. After reading the instructions in the box, carefully put nib size B-2 in the pen and fill the pen with good-quality, water-soluble black ink.

A smooth writing surface is now necessary. It need not be expensive. One perfectly satisfactory solution is a student's drafting board (18 by 24 inches) covered with a sheet of plastic cushioning material. Lay a sheet of Dietzgen drawing paper No. 66 (yellow) the

size of the drawing board on the cushioning material as the actual writing surface and replace it when it becomes soiled.

These materials are readily available at low cost at most office supply stores.

Before starting the exercises, make sure you have assumed the correct writing posture. Put only one sheet of lined notebook paper on the drawing board; the nib pen requires a fairly hard writing surface to function properly.

When drawing with the nib pen, remember to maintain the natural freedom of your hand as you did with the nylon tip pen. The precise formation of broad and fine strokes is what gives calligraphic writing its beauty.

Look carefully at the point of the nib, and you will see that it is not square. It is designed so that it will draw the finest line of which it is capable when moved upward from left to right at approximately a 45-degree angle. Conversely, it will draw its widest line when moved downward from left to right at the same 45-degree angle. Lines of any desired width between these extremes may be drawn by varying the angle of the pen.

Never push the nib pen hard; it is a precision instrument that will deliver the correct amount of ink with minimum downward pressure, as opposed to standard fountain pen nibs, which produce thicker lines with increased pressure at the point.

Before beginning the exercises, experiment with the nib. If your strokes do not automatically turn into broad and fine lines, your problem is one of the following:

- You have a wrong sitting and/or paper position.
- You are not holding your pen correctly. (Always keep the fore-finger in an arched position; otherwise you will lose the light touch that is necessary to produce broad and fine strokes.)
- You have a dirty nib.

After some time (depending on the paper and your "hand"), you will notice (when your strokes look sloppy) tiny particles of paper in the nib. Remove them gently with a paper towel.

After each practice session, remove the nib from the fountain pen, rinse it in cold water, and gently dry it with a paper towel. Then attach the nib to the fountain pen and store it, nib up, in a jar. Rinse

the fountain pen once in a while by filling it with water and then ejecting the water.

When doing the exercises, you will make a mistake once in a while and be tempted to correct it by stroking over it. Resist the temptation! Writing over mistakes is never successful, it will ruin your fountain pen nib (and, later, your delicate calligraphic nib), and it will frustrate you and make you lose your patience. Just keep going. Remember, mistakes are a part of practice, and practice makes perfect.

Practice Techniques

The strokes in the illustrations that follow are essentially the same as the strokes illustrated in Part One of the previous chapter.

Following the *study, trace,* and *draw* practice technique, complete each line of the exercises to your satisfaction before moving to the next.

When you make a mistake—and you will—determine what you are doing wrong and do the stroke correctly after consulting the explanation of the basic strokes in the previous chapter if necessary.

Look at the first line of nib pen strokes. The pen must be held so that the nib will draw a near-vertical, downward stroke that is slanted, or raked, at top and bottom (arrow 1). Held in the same (that is, correct) position, the pen will automatically draw a fine line when the nib is moved in an upward-sideways direction (arrow 2). Determine whether you are holding the pen correctly by drawing fine lines at the tops and bottoms of the remaining strokes in the line.

Trace until you get the feel of how lightly your pen must touch the paper when doing the upward stroke. The lighter the touch, the quicker the movement of the pen.

The straight characters are not easy. In a slow movement, put some pressure on the downward stroke. The more your work matches the illustrations, the easier and faster you will accomplish good calligraphic letter and word formation. Remember, each line must be completed with evenly drawn, uniform strokes, with equal spaces between the figures.

Some basic calligraphic strokes follow on pages 44 to 46.

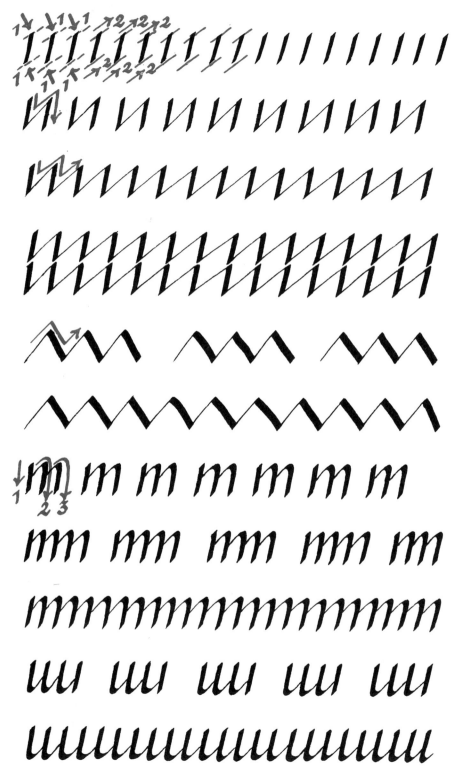

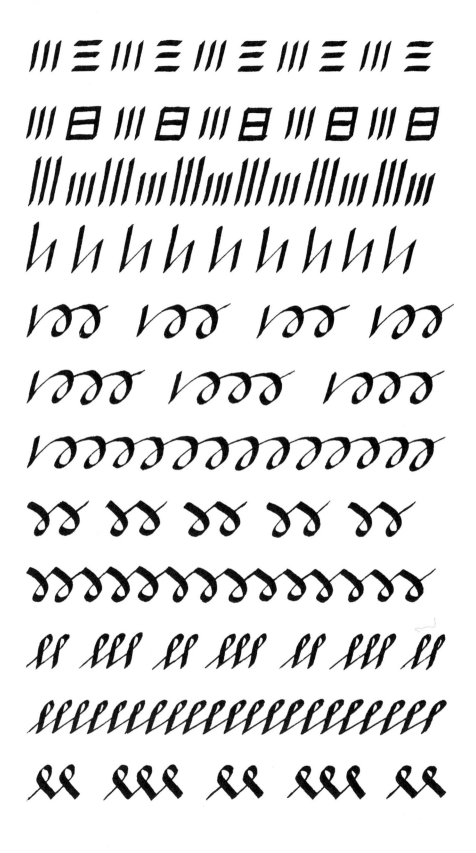

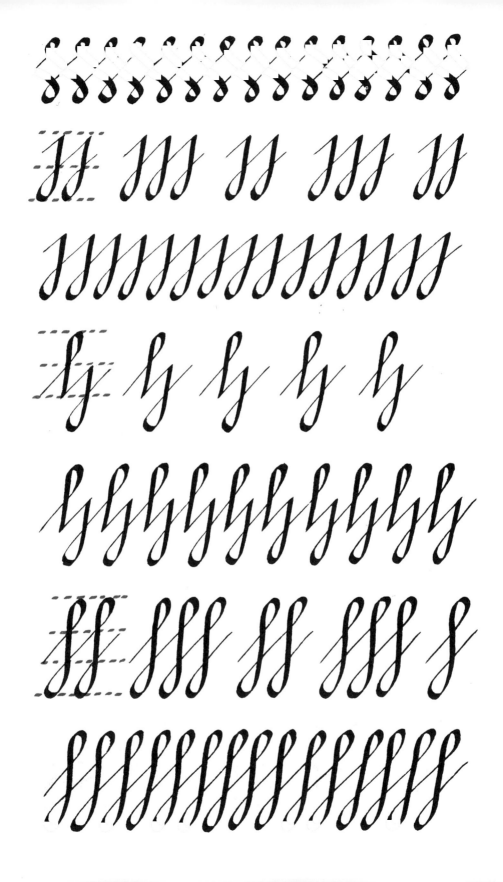

Part Two

The Alphabet–Basic Calligraphic Minuscules

Some letters are drawn with the nib pen somewhat differently from before to produce the broad and fine strokes not possible with the nylon tip pen. These letters are accompanied by instructive numbers and arrows. All other letters are drawn exactly as they were in the previous chapter, and you may find it necessary to refresh your memory by referring to that section as you proceed.

After some practice, your hand will have a freer movement and your nib fountain pen will flow much more easily across the paper than it did with the nylon tip pen. If any of your letters or words do not have exactly the same fine and broad strokes as illustrated, stop—you are doing something wrong! Find out what it is and correct it.

If some letters are more difficult for you to draw than others, trace them over and over again until you get the feel of the stroke. When practicing, constantly compare your work with the illustrations.

As you begin to draw letters and words with the italic nib pen, you must get into the habit of breathing correctly. Your breathing patterns affect the stability of your hand and thus of your stroke. Hold your breath while writing. Exhale and inhale fairly deeply after lifting the pen between words and also before crossing the letters *f* and *t*, putting the dot on the letters *i* and *j*, starting a new line, and so on. This will also lessen the strain on your hand muscles, which is very important. Practice correct breathing; it will soon come naturally, and when it does your writing will improve.

Proper breathing is one reason the calligrapher cannot carry on a conversation while working. The other reason is that concentration is all-important. On the other hand, music may not interfere with your concentration and may even help you work better.

Practice Techniques

As a calligrapher you must have the ability to criticize your own work. One of the ways to do this is the system of proofreading.

Begin your daily practice by checking your work from your previous practice session. Take note of anything that does not look right. Using

a red nylon tip pen, mark weak characters, poor spacing, and whatever else is wrong and correct the mistakes, starting with the easiest ones.

For example, if you find a particularly weak letter, look for a different but similarly formed letter (remember, they often come in groups) that you have done correctly. Then write both letters next to each other, over and over again. In this way, you can improve the weak letter quickly.

In calligraphy you can never afford carelessness or haste. Even if the corrections take up a full practice session (or more), keep at it. Daily proofreading of your work is very important: It is easier to get into a good habit than out of a bad one.

Exercise 1: Trace the strokes between two lines on ruled notebook paper, skipping one line between practice lines to allow enough space for the ascenders. Don't skip more than one line because you must learn to judge with your eye the space needed for even formation of ascenders (and descenders, too, in the following exercises).

/l/l/l/l/l/l/l/l/l/l/l/l/l/l/l/l/l/

lululululululululululul

Exercise 2: The reason the strokes of some letters differ from those rendered with the nylon tip pen is that the nib pen must always be moved toward the right to produce the broadest lines.

aiaiaiaiaiaiaiaiaia

Exercise 3: Like minuscule *a,* the descender *q* begins with a broad, "flat-out" first stroke.

qaqaqaqaqaqaqaqa

Exercise 4: The descender *g* has its first and last stroke flat-out and broad.

g g g g g g g g g g g g

Exercise 5: The ascender *d* is an extension of minuscule *a*. When practicing the word *glad*, watch the width of the flat-out stroke on the waist line in writing the letters *g*, *a*, and *d*; keep the letters narrow. Each descender *g* ends its last stroke exactly like that of the next *g*. (The minuscule *o* between words throughout this section will train your eye to space the words correctly.)

dadadadadadadada

gladogladogladogladogl

quadoquadoquadoquad

Exercise 6: As you practice the *c*, make sure the spaces between the letters are equal.

cacacacacacacac

cudocudocudocudocu

Exercise 7: This is your first exercise in joining letters. Extend the soft ending strokes of minuscules *e* and *c* far enough so that the letters barely touch each other.

Don't rush the word exercises.

ecececececececec

egg egg egg egg egg

glew glew glew glew gle

dog dog dog dog dog

load load load load loa

none none none none

and and and and and

mew mew mew mew m

moow moow moow moo

hew hew hew hew hew

helmohelmohelmohelmo

holeoholeoholeoholeohole

rnrnrnrnrnrnrnrnrn

runorunorunorunorun

ragoragoragoragorag

roaroroaroroaroroar

Exercise 8: Stroke 3 of the ascender *b* is a broad, flat-out stroke on the base line. Keep the letter narrow.

bnbn bn bnbnbnbnb

bobobobobobobobobobo

bugobugobugobugobug

bearobearobearobearo

Exercise 9: To keep descender *p* from becoming plump, make sure Stroke 3 *leaves* the base line. In other words, begin the last stroke close to Stroke 1 (without touching it) and turn it into a small curve. The downward stroke on the bowl of the *p* (Stroke 2) must be parallel with Stroke 1.

Exercise 10: When drawn with the nib pen, descender *j* has an elegant and graceful appearance. Concentrate on making the last stroke flat-out and also on the dots, which must all be drawn at the same height, except between ascenders *f* and *t* (see Exercise 11), where the dot must be lower.

The word *Jim* has two square dots next to each other. Draw the second dot slowly, so that it is identical to the first.

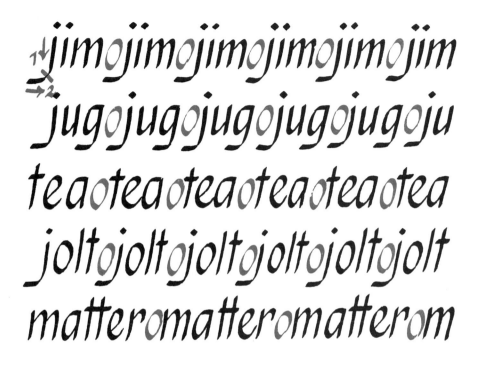

Exercise 11: Ascender *f* is not an easy letter to draw because it must be kept open. The cross-stroke is not permitted to touch Stroke 1. In *floor* and *fitt,* the cross-stroke must not touch the ascender *l* or the dot on minuscule *i.* In the beginning, until you learn to judge with your eye, some awkwardness must be expected. In the word *off,* draw one long cross-stroke through both ascenders.

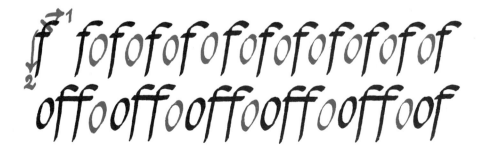

To achieve grace and beauty, don't squeeze dots and cross-strokes between letters. Always remember to leave enough space for dots and cross-strokes when drawing the letters *f, i, j,* and *t.*

Ascenders *f* and *t* need more space. Draw them tall enough to provide sufficient space for their cross-strokes.

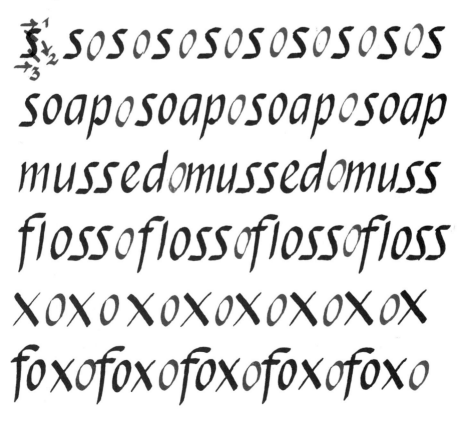

Exercise 12: After a great deal of tracing and practicing, you will be able to draw a good letter more quickly with the nib pen than you could with the nylon tip pen. Concentrate on Stroke 2 of the *s;* Strokes 1 and 3 are flat-out on the waist and base lines.

max o max o max o max

next o next o next o next o

kı kı kı kı kı kı kı kı kı kı kı

kitt o kitt o kitt o kitt o kitt o

knock o knock o knock o

jokes o jokes o jokes o jo

valve o valve o valve o v

vivian o vivian o vivian o v

vessel o vessel o vessel o

will o will o will o will o will

wax o wax o wax o wax

review o review o review

Exercise 13: Descender *y* is also a graceful letter with its broad, flat-out stroke. Strive for uniformity.

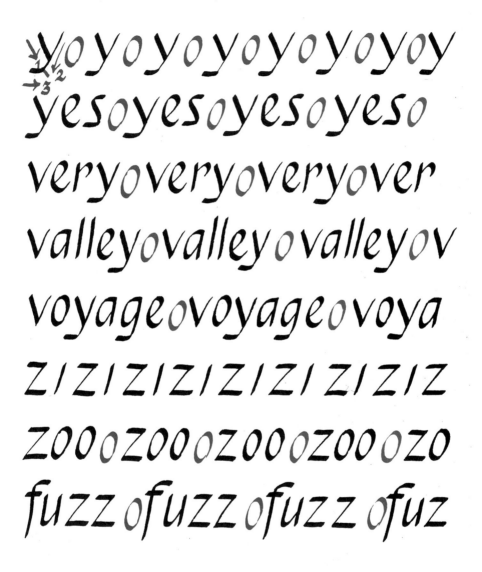

3

Formal Italic and Chancery Cursive Minuscules

Part One

*Basic Flourishment of the Formal Italic
and Chancery Cursive Minuscules
and Their Joining to Form Words*

Materials

> Lined notebook paper
> Red nylon tip pen
> Italic fountain pen and nibs

The development of a standardized handwriting began in medieval Europe under the aegis of church and state.

The writing known as Chancery Cursive, which predates italic, began at the court (or Curia) of the Pope. Then, as now, the Roman Catholic Church had a body known as the Apostolic Chancery, the "office" from which official papal pronouncements were issued.

Pope Eugenius IV (1431–47) was dissatisfied with the grandly ornate style of writing in which the scriveners of the Curia wrote the opinions of canonical lawyers and other papal bureaucrats. He ordered the development of a simple, more legible writing, one that would also increase the scriveners' output. This *Cancelleresca corsiva* became what we know as Chancery Cursive.

Most historians agree that flourished writing began with Niccolo Niccoli (d. 1437). The first printing of flourished letters was in the fifteenth century, using wooden blocks, and the Vatican was probably

the first "publisher" to use such letters extensively. In 1501, Aldus
Manutius of Venice developed the form of slanted writing we now
know as Formal Italic.

Practice Techniques

Formal Italic and Chancery Cursive writing are done in black only;
other colors are inappropriate.

Flourishing letters requires mastery of the fundamental strokes. Stick
to the rules and perform each exercise slowly. The reward will be the
charm and character your handwriting acquires.

Exercise 1: Unless otherwise indicated by arrows, all flourished letters
here are drawn with the same stroke sequence as the basic letters
practiced earlier. The letters in this exercise are the same in both
Formal Italic and Chancery Cursive.

Note that two variations of minuscules *r, v, w, x,* and *z* are shown;
the choice is yours. When you practice words later, you will "feel"
which letter is most suitable for you.

The minuscules *i, m, n, r, u, v, w,* and *z* receive a soft hook at the
beginning of the first stroke. Minuscules *i, m, n, r, t, u,* and *z end* with
a soft hook. Note that the optional, flourished minuscule *r* has a
complete bowl (as if it were a capital letter) instead of a half-bowl.

The last strokes of flourished minuscules *v* and *w* are drawn
downward, not upward. Minuscules *v* and *w* may extend above the
waist line.

Begin with the B-2 nib. Hold the pen as lightly as possible. Make
sure you do not press the thumb hard against the middle finger or
bend the index finger too much. With a slow movement of the pen,
put some pressure on the downward stroke. Use almost no pressure (a
feather touch) on the upward stroke.

Exercise 2: In Formal Italic writing all ascender hooks extend toward the left (except for ascender *t*, which has no hooks at all).

Study and trace the ascenders and descenders, including the two variations of letters *k* and *y*.

Exercise 3: Hooks on Chancery Cursive ascenders extend toward the right only. Descenders have flat-out ending swings. Study, trace, and practice.

Exercise 4: No matter how well a letter is formed, unless it is spaced properly with regard to both the preceding and following letters, beautiful writing—calligraphy—is not possible.

To achieve proper spacing, a system of letter spacing called the counter system is necessary.

A counter is actually drawn at first; later it is only visualized. A counter is an oblong drawn one third as high as the space between the base and waist lines and as close to the vertical lines of the letter as possible.

Between two lines on your ruled notebook paper, trace the exercise with the B-2 nib. Then draw the letters freely. Finally, draw the counters between the strokes with a red nylon tip pen. The counters will of course fit between the vertical strokes of the traced letters, but the freely drawn letters may not permit the counters to fit. If they do not, it will be necessary to practice the strokes until they do. *Make the strokes so that the counters fit!*

Exercise 5: This exercise teaches the fundamental technique of joining. Trace the illustration until your hand moves freely. Then draw the strokes freehand and try to insert the counters.

Exercise 6: When drawing minuscules that begin with a small hook near the waist line, the counters extend downward from the waist line. Practice as in the previous exercises.

Exercise 7: In calligraphic writing there are no specific rules about which letters must be joined and which should not. As a general rule, one should join letters that can be joined easily. Letters that end with the last stroke swinging in a soft curve on the base line are easy to join. Notice in the illustration how the upward curve that ends ascender *d* fits into minuscule *e,* how minuscule *e* neatly joins ascender *b,* and so on, like a string of pearls. Concentrate on the soft curves at the base line; when these are done properly, your counters (placed at the waist line) will fit without trouble.

acdehikklmnu

Exercise 8: When practicing round (or partly rounded) letters, place the counters beside the widest part of the letter (in the center).

oaobcodoeogopq

Exercise 9: These are the only letters in the alphabet that do not fit into the previous groups in using the counter system. Place the counters as shown.

Before beginning the next exercise, memorize the placement of counters. Once this becomes automatic for you, you will be able to space the letters correctly when writing words.

fst ss ff ft

Exercise 10: This exercise forms correctly spaced letters into words. Trace, then draw freely, then insert the counters.

When you have mastered the freely drawn strokes—when your counters fit neatly—you may begin to omit the minuscule *o* between words. Do this at first by holding the pen nib off the paper as you "draw" the *o*. Soon you will develop the ability to draw the spacing *o* only in your mind.

gladoloadohenorun

bugobupojimomatter

fittoflossomussed

nextoknockojokes

valveowilloreview

valleyp veryp zipp fuzz

Exercise 11: This is Exercise 10 drawn in Chancery Cursive.

glad load hen run

bug bup jim matter

fitt floss mussed

next knock jokes

valve will review

valley very zip fuzz

Exercise 12: Do this exercise first in Chancery Cursive and then in Formal Italic, page 65.

Chancery Cursive.

the basic
flourished strokes in
calligraphic writing
are easier to learn
than those of any other
style of handwriting.

Formal Italic.

the basic
flourished strokes in
calligraphic writing
are easier to learn
than those of any other
style of handwriting.

Part Two

Heavily Flourished Formal Italic and Chancery Cursive Minuscules

Materials

> Lined notebook paper
> Italic fountain pen and B-S nib
> Black water-soluble ink
> Draftsman's pencil (Eagle Turquoise 10 or equivalent)
> Type "H" lead fillers
> Draftsman's pencil lead pointer (Eagle Turquoise 17 or equivalent)
> Triangular, 12-inch, wooden draftsman's ruler (Dietzgen
> 31626 or equivalent)

A draftsman's pencil, which holds high-quality lead of the correct hardness in a collet and provides a knurled, metal, nonslip grip for the fingers, is essential in making the fine lines necessary for the techniques of drawing smaller-size letters. Considering its low cost and durability, it is actually cheaper than using wooden pencils.

Furthermore, the lead pointer (sharpener) prepares much finer, longer-lasting points on the lead than the best rotary wooden pencil sharpener can produce. Lead pointers normally come with a device that cleans the point of loose graphite particles after sharpening. The draftsman's pencil will also be used later for other purposes.

The professional-quality draftsman's wooden ruler has perfect straight-edges, a triangular shape, and finger grooves that make it far easier to use than any other kind of ruler. Plastic-covered rulers, available at a higher price, are *not* recommended.

Practice Techniques

To gain a clear understanding of heavily flourished strokes, it is necessary to draw them fairly large at first. Drawing smaller letters may seem awkward to begin with, but after some practice you will find they are easier than the large ones and can be drawn more quickly.

After completing all the exercises on a small scale, you will have

gained both confidence and understanding about what kind of a flourisher *you* are. In other words, you will know, as your pen slides more smoothly and with more rhythm across the paper, which flourishment style—Formal Italic or Chancery Cursive—is for you.

Small letters must be drawn tall and narrow and be packed closely together. Some letters have a tendency to turn into square letters. For example, the minuscule *s,* with its three broad strokes (when it does not leave the base line), should at first be practiced as a large letter. Then you may gradually reduce it, keeping it narrow, to the small size.

Minuscules *x* and *z* may seem difficult, but in addition to their broad strokes they have fine strokes (which minuscule *s* does not have) that help to keep them narrow.

The cross-stroke on the ascenders *t* and *f* may be flourished by starting the stroke with a slightly downward curve and ending it with a slight upswing. When another ascender is next to ascenders *t* or *f,* there is not enough room for this flourished cross-stroke, so it must be begun or ended flat-out.

In heavy flourishment you must learn to think big. Let your pen go when drawing ascenders and descenders! The lettering will be more attractive if you draw ascenders taller and stretch descenders farther downward, rather than make them too short. Their length, if not overdone, is what gives them grace.

Pay attention to descender *p,* which can turn into a plump letter if its last, upward stroke is not properly drawn.

Remember that certain letters are drawn in two somewhat different ways. After you decide which version is more suitable for you, use it throughout; do not mix variations of the same letter.

Exercise 1, Formal Italic: On your ruled notebook paper measure ¼ inch from the base line upward and draw a line across the page with the draftsman's pencil. This will be the waist line for the smaller-size letters.

Using the B-S nib (slightly smaller than the B-2), trace the alphabet and practice the words that follow. Notice that the hooks on ascenders *b, d, h, k,* and *l* can be drawn in one of two ways; choose the one you like better. Pack the letters closely together, as illustrated. Always finish the word before putting the cross-stroke on ascenders *f* and *t.* If the minuscules *i* or *j* are also in a word, draw the dot before the

cross-stroke, so you know how much space you have left for the cross-stroke. Remember, you must not squeeze anything into a word.

Ascenders and descenders glitter like jewelry. Because of their prominence, their size and shape must be perfect. With a slow movement, put some pressure on the downward stroke and let your ascenders stand tall and lean slightly toward the right. The same rule applies to the descenders: Each must be identical in size and shape to the following descender.

Don't cheat yourself by moving from one exercise to the next too quickly. Proofread daily and correct any weak letters you find right away. If you feel as though you are being pushed into a corner (which could mean that you are tired), quit for the day and begin with that particular letter the following day.

abcdefghijklmnopqrstuvwxyz

b d h k k l b d h k k l

*hard work in calligraphy
is worthwhile and rewarding
and will give your writing
character and distinction.*

Exercise 2, Chancery Cursive: After drawing additional ¼-inch lines on the notebook paper, form the letters and words here using Chancery Cursive.

abcdefghijklmnopqrsstuvwxyz

b d h k k l b d h k k l

a great deal of
understanding and knowledge
comes from
the disciplined exercises of
the calligraphic hand.

Exercise 3: In this exercise, "mother's apron" is gone and you no longer use the ¼-inch penciled waist line on your notebook paper. From now on, you must judge the size of minuscules with your eye. First trace the exercise, then draw it freehand, making the hooks and swings in the manner you prefer.

In calligraphy, daily exercises and proofreading are needed to build a disciplined calligraphic hand aided by a practiced eye instead of ruled lines. It takes time and patience to develop a natural feeling in your hand and mind. Don't hurry; if you try to achieve fluency prematurely you may develop bad habits.

the most important tool for a
calligrapher is his trained
eye; it becomes his ruler.

do not try to force a certain style
because it looks good to you;
anything in calligraphy that
is forced looks artificial.

By now you should know whether you are naturally a Formal Italic
or a Chancery Cursive flourisher. Choice of one style of flourishment,
however, does not mean you cannot borrow from the other. If, for
example, you are a Formal Italic flourisher you may use the flat-out
strokes of Chancery Cursive (or vice versa) if this is more natural for
you.

The important rule to remember is that once you choose a style for
ascenders and descenders, stick with it. You must not vary the way
you draw each letter.

Heavy flourishment is not a necessity. If you prefer basic flourish-
ment because its simplicity appeals to you, then by all means do not
force yourself to use heavy flourishment.

Exercise 4: If you are not a heavy flourisher, disregard Exercises 4 and
5. These exercises may also prove too complicated for beginning heavy
flourishers unless they have practiced a great deal and mastered a
chosen style of heavy flourishment.

These letters, whose final strokes end in large, rightward swings
below the base line, are called *letters with a tail* and are used either to
finish a sentence or, at the end of the writing line, to kill extra white
space. Move the pen swiftly when drawing the tail, and put in the
period or comma afterward, as shown, without touching the tail
stroke.

Exercise 5: The letters *r, l, k,* and *q* may be drawn with their tail strokes extending under the following letter(s). These tails must not crowd your writing; if they do, they will lose their graceful appearance and legibility.

the word pen comes from

latin- penna - and

originally meant a feather.

goose feathers were used

to make pens - called quills.

4

The Calligraphic Nib Pen

Materials

Lined notebook paper
Red nylon tip pen
Heintze & Blanckertz Signum Toka No. 6 pen holder and nib set
Black India ink (Higgins, Pelican, Grumbacher, or equivalent)
Water jar
Higgins pen cleaner (six-ounce size)
Paper towels
Small box for storing nibs
File folder

The Heintze & Blanckertz pen set is specified for two reasons. First, I know of nothing better on the market at any price than this very inexpensive calligrapher's tool. Second, the set includes a specially shaped wooden nib holder. The wide flat base of this double-ended holder rests comfortably against the middle finger and makes holding the pen incorrectly almost impossible. Rest your forefinger (which must be arched constantly) on the right side flat base, and your thumb on the left side flat base, leaving the top flat base open. In other words, do *not* rest a finger on the ridges. Otherwise you will lose the proper balance of your pen holder, which will result in poor lettering.

The set also includes six high-quality nibs ranging in size from ½ to 2½ millimeters.

The Higgins pen cleaner is a jar of solvent complete with a retrieving tray. This very inexpensive aid is essential.

Calligraphic nibs are more precisely shaped than italic fountain pen nibs. If given proper care, they will last for many months. If abused, however, the delicate nibs can be quickly ruined.

There are many different nibs on the market. I have found those made in Germany by Heintze & Blanckertz to be the most dependable.

The exercises are given in millimeters according to the measurement of Heintze & Blanckertz nibs furnished with the pen set.

New nibs are oily. The oil must be burned off by holding the nib in a match flame for a moment.

Attached to the nib is a reservoir that holds a small supply of ink and permits an even flow. Ink must flow smoothly through the slit in the tip of the nib to make fine and broad strokes possible.

Fill the reservoir three quarters full with the ink bottle dropper. Keep the ink bottle off the drawing board on the left side of your working place. From the beginning, use your left hand to fill the reservoir. Changing hands whenever the pen needs ink would become very time-consuming.

When beginning to write or after refilling the reservoir, ink sometimes does not flow instantly into the nib tip. When this happens, do not push the nib hard against the paper; this will ruin the delicate nib. Instead, on a sheet of notebook paper kept on the left side (off the drawing board), drop a small amount of ink and dip the pen in it. Then draw a few short broad strokes on the paper. This will immediately cause the nib to work as it should.

If the nib pen is not to be used for more than a couple of minutes, dip it in a jar of water (placed to the right of the drawing board) and then dry it gently with a paper towel. This will prevent ink from drying on it and clogging the slit and the reservoir.

After practicing awhile you may notice that your strokes are no longer as fine and sharp as they were. This indicates that some ink has already dried on the nib and begun to interfere with its proper functioning. Rinse the nib well in water. Dried ink (or any small bit of debris) caught in the nib will not only ruin your writing but damage the nib as well.

By the end of each working session, the nib will be fouled by dried ink pigment. It must be soaked at least overnight in a special solvent to remove the pigment, then rinsed in cold running water and dried thoroughly with a paper towel. Failure to do this will ruin the nib.

The reservoir must be carefully dried; take care not to bend it. Nibs not in use should be stored in a small box.

Compared to regular fountain pen ink, India ink appears much blacker on a white surface. When drawn with India ink, ascenders and descenders show up more clearly and mistakes are more easily seen.

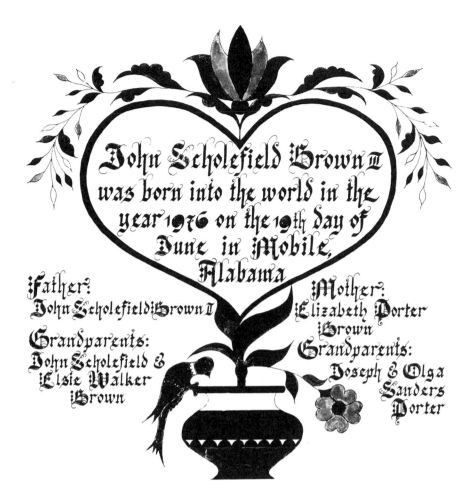

John Scholefield Brown III
was born into the world in the
year 1976 on the 19th day of
June in Mobile,
Alabama

Father:
John Scholefield Brown II

Mother:
Elizabeth Porter
Brown

Grandparents:
John Scholefield &
Elsie Walker
Brown

Grandparents:
Joseph & Olga
Sanders
Porter

Plate I: Birth Announcement; 11 by 14 inches; gold, green, red, blue, light blue, orange, and yellow. This design shows the influence of Pennsylvania Dutch designs.

Draw the black massed text (child's name, date, and place) first, then center it.

From the center of the top line draw the left half of the heart outline with a draftsman's pencil. Then draw a second line one eighth inch outside the first.

Trace the two lines of the half heart on drafting paper.

Turn the drafting paper over, slide it under the draft, and use the lines to complete the other half of the heart. (The double-lined heart outline will be filled with red enamel.)

For decoration, let your imagination soar:

On drafting paper, draw curving lines around the left side (only) of the heart outline.

Select border designs (and colors for them), and arrange them on the curved lines.

Turn the drafting paper over to produce the mirror image, as you did to draw both sides of the heart.

Colored border designs placed between parents' and grandparents' names are also appealing.

The calligraphic nib pen does not have as soft a touch in writing as the italic fountain pen. If you turn the calligraphic pen holder too much toward the right, the left side of your stroke will appear ragged; if the pen leans too much to the left side, the right side looks uneven. Reread the discussion of how to hold the nib pen at the correct angle in the second chapter.

To be absolutely sure that you are not making any mistakes, also reread the discussion of the calligrapher's posture and practice techniques in the first chapter.

Before you start using the calligraphic nib pen, make sure:

- Your chair is turned slightly toward the left.
- Your feet are in a comfortable position.
- You are not slouching over your writing surface.
- You have removed all jewelry.
- Daylight (or light from a table lamp) is coming over your left shoulder.

As you begin to master the calligraphic nib pen, remember to:

- Breathe correctly.
- Move the paper back and forth, not your hand.
- Wash your hands frequently.
- Proofread your previous work at the beginning of each exercise.

Practice Techniques

Continue to write as you did with the fountain pen, repeating the large flourished letters of the previous chapter with the 2-millimeter nib. When you have done this to your satisfaction, draw the small-size letters with the 1½-millimeter nib.

Then practice on your own by choosing a small poem with short words and lines. Copy it with the 1½-millimeter nib in small-size writing on a lined sheet of paper. When you have completed the poem, proofread it carefully. Mark defective letters and poor word formation with a red nylon tip pen. When you copy the poem again, your eye will be drawn to the mistakes you made the last time and you won't make them again.

Repeat this drawing-proofreading-redrawing process until you are pleased with your work. Then move on to pages of writing containing longer words and sentences.

From now on put your best work in a file folder. Referring to it will help you see how well you are progressing.

5
Formal Script
(Heavyweight Minuscules)

Materials

 Lined notebook paper
 Black and red nylon tip pens
 Draftsman's pencil and sharpener
 Calligraphic pen holder and nibs
 Black India ink
 Ruler
 Soft eraser (flat, Eberhard Faber No. 100 or equivalent)
 Cross-sectioned ruled graph paper 8½ by 11 inches, four squares per square inch
 Drawing ink (waterproof) in bright colors of red, green,
 and blue (Higgins or equivalent)
 Higgins pen cleaner
 File folder

Minuscule Formal Script letters (characterized by straight up and down strokes that are wider and heavier than those of Formal Italic or Chancery Cursive) were adapted from the Roman alphabet. Formal Script is the most widely used style in calligraphy. Before the first printers copied its characters to make type, Formal Script was called the "Book-Hand." The letters have an elegant simplicity. Formal Script does not have majuscules (capital letters), and Roman letters (with or without illumination) are used.

Except for the small hooks (which are optional) on ascenders and the short, flat-out descenders, only the basic style of Formal Script will be discussed here. Flourishment of the basic style requires a skill and knowledge that comes only to the experienced calligrapher.

The strokes of the letters are drawn like those of the minuscules in the second chapter, except that Formal Script is drawn:

- Vertical, not slanted.
- Short, not tall.
- Round and/or square, not narrow.

Exercise 1: With a black nylon tip pen draw the Formal Script alphabet on cross-sectioned ruled paper. As illustrated, all but two letters should fill one ¼-inch square; minuscules *m* and *w*, because of their width, fill two squares. Ascenders and descenders also extend beyond one square. Letters with a bowl are drawn to touch three sides of the square. Ascenders and descenders must be drawn short to achieve the necessary heavy look.

a b c d e f g h i

j k k l m n o p q

r s t u v w x y z

Exercise 2: Repeat Exercise 1 with the 1½-millimeter nib.

Exercise 3: Draw a pencil line ¼ inch above the ruled lines of a sheet of notebook paper to make a lower waist line. Trace the letters with the 1½-millimeter nib.

The feel of heavyweight letters may be awkward at first. Trace them until you can draw them well freehand.

For legibility between other letters, turn the half-bowl of minuscule *r* slightly inward.

Minuscule *s* may need more attention. Practice a slightly larger-size minuscule *s* until it comes naturally, then slowly reduce it in size.

The letters *h, m,* and *n* have wide arches. The minuscule *u* has a wide inverted arch.

abcdefghijkklmno

opqrstuvwxyz

Our Wedding Vow

To have and to hold
from this day forward,
for better for worse,
for richer for poorer,
in sickness and in health,
to love and to cherish,
'till death do us part.

Stephen James & Cynthia Jensen Davenport
married April 14, 1976
The Church of the Redeemer
Westport, Connecticut.

Plate II: Wedding Vow; 11 by 14 inches; gold, green, red, and blue. First draw the black massed text inside the frame. Then decide which lettering you wish to use for the title, and choose the ornamental designs you want to use for the frame. Draw the names, date, and so on last.

Exercise 4.

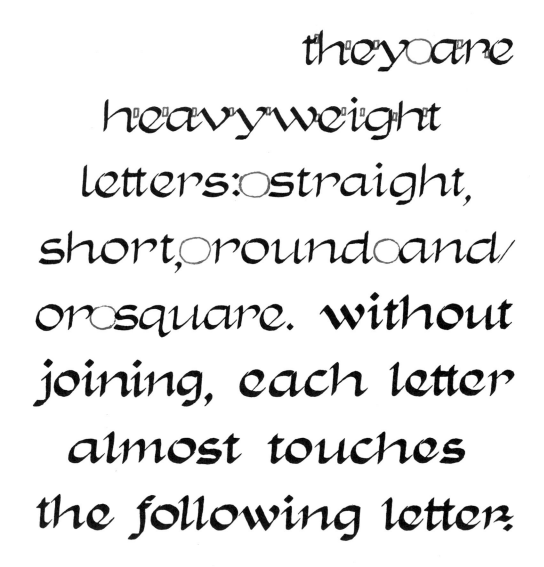

they are
heavyweight
letters: straight,
short, round and
or square. without
joining, each letter
almost touches
the following letter.

Exercise 4: Although it appears to the eye that Formal Script letters are joined, they are not. This illusion is called *almost-touch,* which means that each minuscule gives the appearance of almost touching the following one. These are called *closed letters*, and one should think of a closed formation when making words out of them.

Use the counter system (employed earlier in drawing flourished minuscules) of arranging the letters and words. The widest part of each letter almost touches the widest part of the following letter. Since there is no joining in Formal Script (although some letters ending in curves may join naturally), the counter system is very important to achieve uniformity among the heavyweight letters.

Spacing between words is accomplished by the use of a minuscule *o that touches both letters.* It is first actually drawn, and then drawn only in the mind. It goes without saying that the spacing *o* should also be in the Formal Script style.

First draw the exercise with the 1½-millimeter nib, and then with the 2-millimeter nib.

Exercise 5: Because Formal Script and Roman letters are so heavy, a word containing a double *o* with the two letters placed side by side would lose much of its grace. They should be drawn overlapping. Begin the second minuscule *o* on the upper right side (note arrow) of the first minuscule *o*.

Draw this exercise first with the 1½-millimeter nib, and then with the 2-millimeter nib.

Exercise 6: The ampersand (the symbol for the word *and*) is derived from the letters *ET*, which is *and* in Latin. While there are several variations of the symbol, the one shown is both easy to learn and very appropriate for Formal Script (and flourished writing). Note carefully the direction of the arrows.

Exercise 7: After you have drawn the sample sentence with the 2-millimeter nib to your satisfaction, you may try writing short sentences and short poems, using the proofreading system to check your work.

A natural writing ease will come to you only through a considerable amount of disciplined practice. You may also wish to experiment with brightly colored inks.

Since colored ink tends to flow through the reservoir more quickly than black India ink, it is a good idea to draw a few short test strokes on a sheet of notebook paper.

formal script has a graceful & distinctive look.

6
Arabic and Roman Numerals

Materials

Lined notebook paper
Black nylon tip pen
Draftsman's pencil and sharpener
Ruler
Calligraphic pen holder and nibs
Black India ink
Pen cleaner
File folder

Arabic Numerals

What we call Arabic numerals actually were developed in India, and reached the West by way of the Arabs.

In calligraphy, Arabic numerals must be drawn legibly and with grace through the use of fine and broad strokes. Like Formal Script, Arabic numerals have a heavy look. The top of numeral *3* may be either flat or softly curved. Numeral *7* may be written in the old calligraphic style (still used by most Europeans) with a cross-stroke drawn through the vertical stroke, or drawn in the modern fashion without a cross-stroke.

Exercise 1: Study and trace with the black nylon tip pen to get the feel of the correct proportions. Numerals *1*, *2*, and *0* fill the space between two lines on lined notebook paper. Numerals *3*, *4*, *5*, *7*, and *9* leave the base line like descenders. Numerals *6* and *8* leave the waist line like ascenders.

Exercise 1.

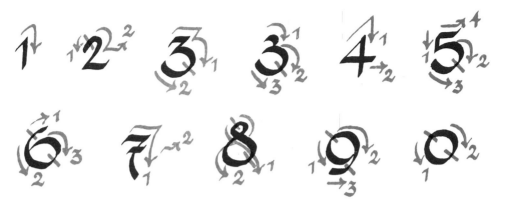

Exercise 2: To arrange the numerals correctly, use the counter system. The widest part of each numeral should almost touch the widest part of the following numeral.

Draw a pencil line ¼ inch above the base line to use as a guide while drawing the smaller-size numerals. Practice the exercise with the 1½-millimeter nib.

1234567890 3

Roman Numerals

Roman numerals are nothing more than Roman letters, either majuscules or minuscules, used singly or in combination as numerical symbols. They are still used today in text for various purposes and on some public buildings.

Roman numerals are usually drawn the same size as the minuscules of the letters that comprise them. As illustrated in Exercise 3, they are heavyweight letters, drawn as wide as Formal Script and packed closely together.

In the illustration, "Anno Domini—MCMLXXV" is written in another style that combines Roman letters and Roman numerals, drawn identically. (The flourishment, rendered by the use of serifs, will be explained in a later chapter.)

Exercise 3: Draw a pencil line ³/₁₆ inch above the base line to use as a guide line. Practice the exercise with the 1½-millimeter nib.

I 1 · II 2 · III 3 · IV 4 · V 5 · VI 6 · VII 7 · VIII 8

IX 9 · X 10 · XI 11 · XII 12 · XIII 13

XIV 14 · XV 15 · XVI 16 · XVII 17

XVIII 18 · XIX 19 · XX 20 · XXV 25

XXX 30 · XXXV 35 · XL 40

XLV 45 · L 50 · LV 55 · LX 60

LXX 70 · LXXV 75 · LXXX 80

XC 90 · C 100 · CXXV 125 · CL 150

CC 200 · · CCL 250 · · CCC 300

CD 400 · D 500 · DC 600 · DCC 700

DCCC 800 · · CM 900 · · M 1000

ANNO DOMINI ⁜ MCMLXXV

7

Basic Roman Letters and Flourished Italic Capital Letters (Majuscules)

Materials

Lined notebook paper
Cross-sectioned ruled graph paper 8½ by 11 inches,
 four squares per square inch
Black nylon tip pen
Calligraphic pen holder and nibs
Draftsman's pencil and sharpener
Eraser
Black India ink
Pen cleaner
File folder

One of the landmarks in Rome is the Trajan Column, a 147-foot monument to the Emperor Trajan erected A.D. 114. The inscription carved on the column is probably one of the earliest and finest examples of Roman lettering. Roman letters of this type are the basis and inspiration for all Western alphabets used since.

Since flourishment originated with Roman letters, mastering *basic* Roman letters before attempting flourished italic majuscules will make learning this type of flourishment much easier. (A more complete discussion of Roman letters appears in a later chapter.)

The Roman alphabet has both heavyweight letters like Formal Script and lightweight letters like flourished italic minuscules. A numbering system is used to identify the several types of Roman letters:

- "1" means that a letter is a *heavyweight* letter and *fills the width of a full square*. ("D" does not quite fill the square.)

- "¾" indicates a letter that is not quite as heavy as a No. 1 and which *fills three quarters of the width of a square.*
- "½" designates a *lightweight* letter that *fills half the width of a square.*

Practice Techniques

Study the proportions carefully before tracing. There are six types of letters to be mastered:

1. Round letters (Line 1).
2. Triangular letters (Line 2). None of these is placed within the square in exactly the same way as the others.
3. Narrow letters (Line 3).
4. Letters with several diagonal strokes (Line 4).
5. Letters with straight downward strokes (Line 5).
6. Letters with one long diagonal stroke in the center (Line 6).

Because the straight strokes of the Roman letters in Line 5 are not slanted toward the right, keep the paper in a *vertical* position when drawing them. To accomplish proper broad and fine calligraphic strokes, tilt your paper toward the *left* when going over the penciled strokes of the letters with the nib pen.

Exercise 1: With the illustration before you in a *vertical position,* place a sheet of cross-sectioned ruled graph paper over it so that the letter is centered within a one-inch square. Trace each letter with a black nylon tip pen. Make sure your strokes are made in the directions indicated by the arrows.

Then practice the letters freehand on a sheet of cross-sectioned paper until you understand the correct proportions of each letter and how it fits into the square. Check your work constantly against the correctly traced letters and the illustrated ones.

The ¼-inch squares into which the cross-sectioned paper is divided will help you learn exactly how each letter is drawn by providing a handy means of precisely locating within the larger square the beginning point, the path, and the end point of each stroke. For example, Stroke 3 of letter *G* (the horizontal stroke) begins ⅜ inch from the base line, *not* on the center line. Stroke 1 of letter *D* is drawn ⅛ inch from the left side of the square rather than on the left side of the square. Stroke 3 of letter *E* is drawn ⅝ inch from the base line, rather than equidistant from the top of the letter and the base line.

Exercise 1.

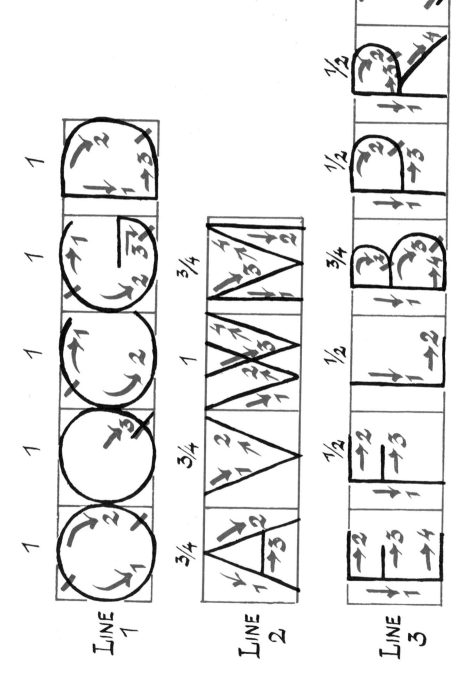

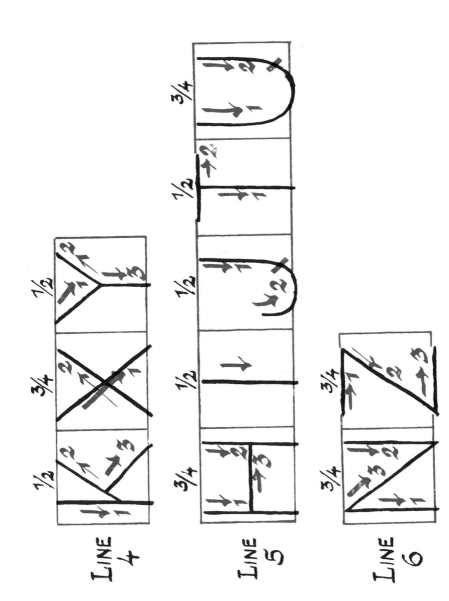

LINE 4

LINE 5

LINE 6

Exercise 2: This exercise duplicates Exercise 1, except that here the letters are drawn within a ½-inch square. When you have drawn them to your satisfaction with the nylon tip pen, repeat the exercise using the draftsman's pencil and then go over the letters with the 1½-millimeter nib.

Exercise 3: Since the Roman letters of Exercises 1 and 2 are the basis of all other majuscule letter styles, the strokes used to form other majuscule letters are based on the "Roman strokes." (Flourished italic majuscules, however, are slanted toward the right and require tilting your writing paper toward the left.)

In this exercise the basic flourished majuscules are formed with curved lines and swings, some of which require an extra stroke.

If you have difficulty drawing the basic flourished majuscules, the probable cause of the trouble is that you failed to really master the basic Roman alphabet in Exercises 1 and 2.

Like Roman letters, basic (and heavily flourished) italic majuscules must be well balanced. With a black nylon tip pen trace the large-size letters on lined notebook paper, using three lines. Repeat with the 2-millimeter nib and black ink until you remember the strokes. Practice until you are able to draw the basic style well.

have lived and loved together
through many changing years;
we have shared each other's gladness,
and wept each other's tears.

CHARLES JEFFREYS

For Charles Kenyon & Grace Dowson Porter
with the love of their children
on their 50th Wedding Anniversary.

Plate III: Fiftieth Wedding Anniversary; 11 by 14 inches; gold, blue, red, and green. Much imagination is needed when designing the first word, *We,* and for the frame of colored border designs around it. If the occasion is the twenty-fifth (silver) anniversary, illuminate *We* in silver rather than gold.

Exercise 4: Practice the small letters with the 1½-millimeter nib. Note that the upper portions of the letters rise slightly above the line.

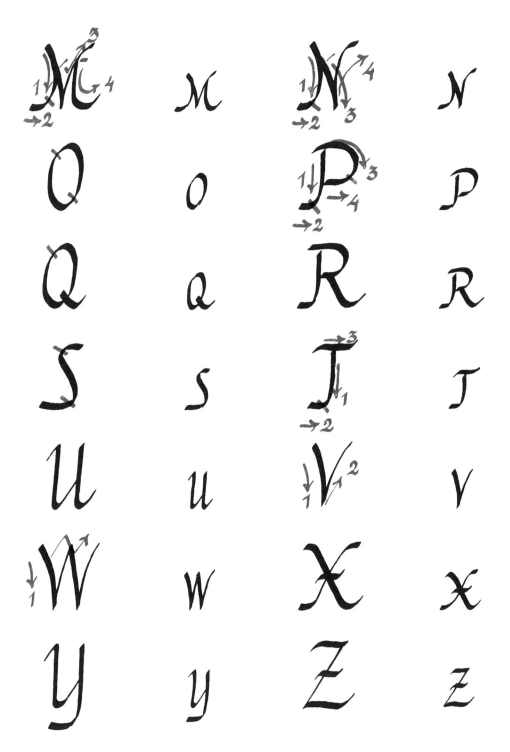

Exercise 5: Practice with the 1½-millimeter nib until your writing is almost identical to the illustration.

America Belgium China

Denmark England France

Germany Holland Italy

Japan Korea Lisbon

Mexico Norway Orient

Paris Quebec Rumania

Sweden Turkey Ural

Vienna Warsaw Xenia

Ypres Zurich

Exercise 6: This example is designed to give you a clearer understanding of heavy flourishment. Study the strokes and memorize their names.

- Adding fancy strokes (Strokes 1 and 4) is called *tapering on top*.
- Stroke 2, which is long, is called a *stem*.
- Stroke 3, which swings wide, is called *tapering at foot*.
- Strokes 5 and 6 form a large *bowl*.
- Stroke 7 is a wide curve and is called a *tail*.

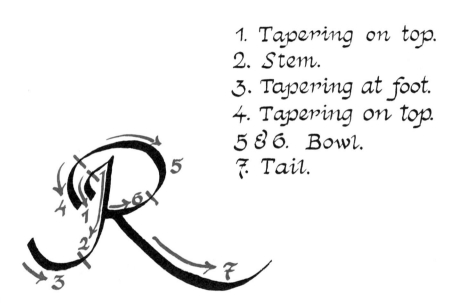

1. Tapering on top.
2. Stem.
3. Tapering at foot.
4. Tapering on top.
5 & 6. Bowl.
7. Tail.

Exercise 7: If not otherwise indicated by arrows, the strokes in heavy flourishment are the same as those in basic flourishment. Use a 2-millimeter nib and let your pen move freely and smoothly. Apply some pressure on downward strokes. Concentrate on developing a feather-light upward stroke, drawn more quickly than the downward stroke.

If one particular letter gives you more trouble than the others, skip it until you have finished the alphabet and then return to it. To master flourishing takes a great deal of patience, so don't be discouraged. No one has ever become a skilled flourisher in a short time.

Exercise 8: Repeat Exercise 7 using a 1½-millimeter nib.

Exercises 7 and 8.

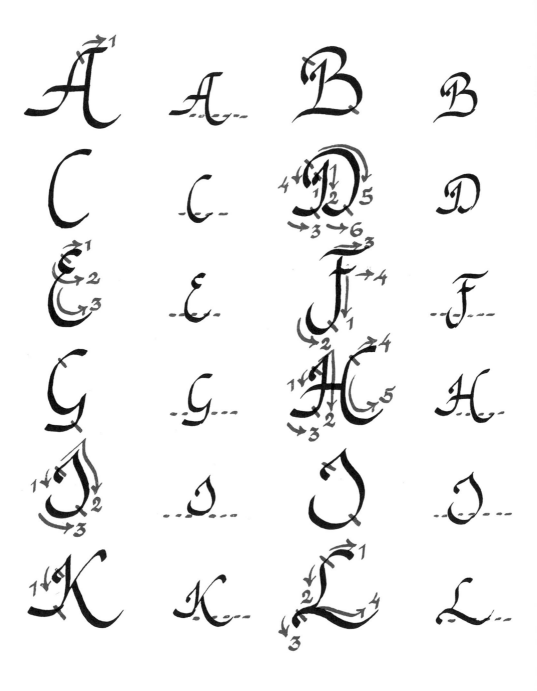

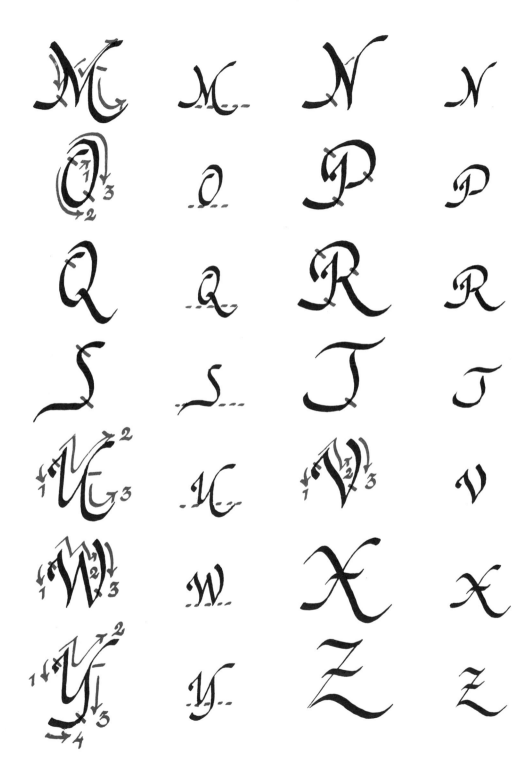

Exercise 9: Practice the exercise words first with the 1½-millimeter nib until you have complete control over your work. The illustration has been prepared with the 2-millimeter nib because it is more difficult to use. Do not do the exercise with the 2-millimeter nib until you are completely satisfied with your work with the 1½-millimeter nib.

After some practice combining majuscules with minuscules, you will find out what kind of flourisher you are: whether you prefer heavy flourishment with sweeping tails, flourishes that leave the base line when tapering at foot, or both. If heavy flourishment does not come easily for you even after a great deal of practice, don't force it. Instead, you may prefer to mix basic flourishment with *some* of the heavily flourished style.

In joining flourished majuscules, visualize them as minuscules. If the last stroke of a majuscule ends in a curve on the base line, it joins neatly with the next letter. When ending a majuscule in a tail, put the following minuscule close to the majuscule, almost molding it into the tail stroke. This is a very effective style of flourishment, but it requires a great deal of practice before a graceful appearance can be achieved.

There are no rules for joining except that majuscules must always be recognizable as such in the mass of the text.

Practice on your own by choosing short poems, passages from the Bible, and so on. Keep your best work in a file folder as an indication of your progress.

Exercise 9.

Alice Barbara Charles

Doris Edmund Frances

George Helen Irene

John Kenneth Louis

Mary Norma Oliver

Paul Quincy Ronald

Susan Thomas Ulrich

Vera William Xavier

York Zoroaster

8
Arranging the Page
Word Division, Punctuation, Abbreviation, Fluency, and Breaking of the Text

Materials

Lined notebook paper
Calligraphic pen holder and nibs
Black India ink
Pen cleaner

Word Division

Since calligraphy must be both beautiful and legible, take care in dividing words at the ends of lines. If at all possible, words should not be broken, and names, places, and dates should never be broken. It is much better to fill in the empty space at the end of a line with a suitable calligraphic design, or *line finishing,* which will be discussed at length later.

It is sometimes necessary, of course, to break a word at the end of a line, and some words (for example, "semi-annual") can include a hyphen. In either case the dividing mark must be clearly recognizable.

Exercise 1: Draw with the 1½-millimeter nib the broken words and their hyphens.

re— semi-annual

Punctuation

Exercise 2: Ampersands and parentheses in a text are drawn the same height as the ascenders. Practice with the 1½-millimeter nib.

Exercise 3: Exclamation marks, question marks, and single and double quotation marks are drawn the same height as the majuscules in a text.
Punctuation marks do not touch adjacent letters.

Abbreviation

Except for the obvious (Mr., Mrs., Dr., etc.), abbreviations really have no place in calligraphy and should be avoided.

Fluency

There is a considerable difference between speed and fluency. Calligraphy obviously cannot be done hastily; haste really does make waste. On the other hand, calligraphy is not improved by a too-cautious pace. Fluency, which may be described as moving along as fast as high-quality performance will permit, actually improves the overall quality of the manuscript.

Practice Techniques

Fluency comes from the confidence that develops with mastery of the strokes. To achieve fluency, application of the basic rules is important:
- Hold the pen as lightly as possible to avoid muscle strain in your hand.
- Don't press the thumb hard against the middle finger or bend your index finger too much.
- Rest your hand frequently by lifting the pen off the paper when drawing dots, dashes, and so forth.

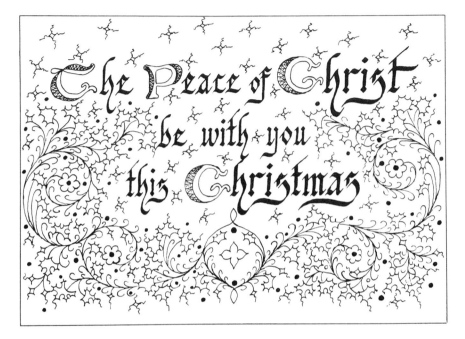

Plate IV: Christmas Greeting Card; 12½ by 9 inches; folded to 6¼ by 4½ inches; gold, green, and red. This is a Christmas card I have sent on behalf of my family. It was drawn on one side of a sheet of Parchain paper and then "French folded." Draw various colored border designs, and illuminate both *C* majuscules in gold only.

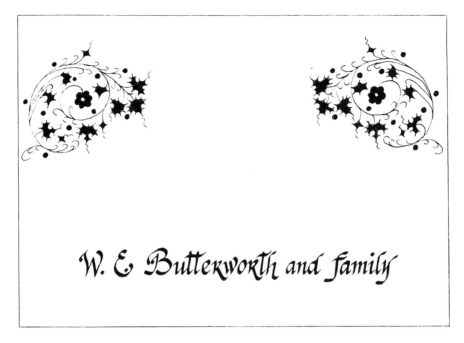

Plate V: Christmas Greeting Card Name Inscription; black, red, and gold. After the Christmas card has been folded, unfold it and draw in your name and border designs.

Choose a short, page-filling paragraph with simple words and small sentences. Copy it on a lined sheet of paper with the 1½-millimeter nib in small-size writing. Draw precise, slanted strokes, evenly sized and equally spaced letters, and evenly spaced words. Try to achieve an overall appearance of legibility and grace.

Having completed the page, proofread it carefully. If everything looks good to you, do it again, this time striving for fluency. Try to make the writing flow smoothly from your pen.

After proofreading your second version, do it a third time, trying for even more fluency. You will know you are going too fast if you begin to make mistakes.

As you try to acquire fluency, ascenders and descenders will tend to lose their evenness. Other letters may also become faulty. Find the weak letters and mark them with a red nylon tip pen. As you recopy the page, your eye will be drawn to the mistakes you made the last time and you won't make the same mistakes again.

Now, mark the mistakes on this version with a red nylon tip pen and use it as the text to copy. Eventually you will write a page with only minor errors. Perfection is no more possible in calligraphy than in anything else, although the conscientious calligrapher constantly strives for it.

Breaking of the Text

Proper breaking of the text requires not only an eye for visual grace, but also an understanding of the rhythm and meaning of the text. The calligrapher, after all, is the direct descendant of the scrivener, whose task it was to transmit ideas beautifully and clearly by means of the written word. The challenge of breaking up a solid mass of text so that it is intellectually *and* esthetically satisfying is perhaps the most difficult challenge the calligrapher faces, and the most rewarding.

One line of a poem, for example, may be followed by a line of equal artistic and emotional significance, but twice as long (or half as long) as the preceding line. It is then necessary for the calligrapher to decide how to present an artistically satisfying physical arrangement of the words while retaining the poet's thoughts and rhythm. Sometimes a blank space will do the trick; in other situations rather elaborate line-finishing designs must be used to show the reader where the poet intended a pause. In any case, calligraphy must not be allowed to overwhelm or distort the thoughts expressed by the words.

9
Your First Public Exhibition

Materials

 Lined notebook paper
 Black nylon tip pen
 Draftsman's pencil and sharpener
 Ruler
 Calligraphic pen holder and nibs
 Black India ink
 Pen cleaner
 Calligraphic stationery and envelopes
 File folder

By now you have progressed far enough so that people will really appreciate a gift sample of your calligraphy. Short verses from the Bible, poetry, even letters not only will be welcome but will provide you with practice to keep you on your toes.

Calligraphic stationery pads are attractive and provide at very reasonable cost a writing surface designed for the calligrapher's pen. Pads of different-colored paper and matching envelopes are available in art supply stores.

First, you must prepare your own guide sheets, which will also be used when working on manuscripts later.

Guide Sheet No. 1: With the draftsman's pencil draw ½-inch lines across a white sheet of paper and trace them exactly with the black nylon tip pen. Do not use a narrower width, or your flourished majuscules, ascenders, and descenders will lose their elegant appearance and legibility.

Guide Sheet No. 2: With a black nylon tip pen and ruler, draw over the top line of a sheet of ruled notebook paper. Continue to the bottom of

the paper, skipping a line between each drawn-over line. This will give you guides $^{11}/_{16}$ inch apart. When not in use, keep both guide sheets in a folder.

Now that you are preparing manuscripts that others will see, a little more care when working is necessary. No matter how clean your hands are, they will leave an oily deposit (often virtually invisible) on the manuscript paper. Since one such smudge can result in a botched letter or word and ruin the entire manuscript, extra caution is advisable. Place a sheet of paper where it will protect the manuscript from your writing hand as you work your way down the page. Dusting your hands with talcum powder may sometimes be necessary. Replace the protective paper when necessary and always after each work session.

Letter-size stationery (8½ by 11 inches) is just about the right size for a small manuscript. If, after drawing a number of small manuscripts to your satisfaction, you want to try something larger, take a sheet of the calligraphic stationery as a sample to an office supply store or a printer. They will be able to supply larger sheets of the right kind of paper from their stock.

As you acquire greater understanding of flourished italic majuscules, let your imagination run freely. Create your own distinctive letters. The only rules are that the majuscules must be legible and must harmonize with the flourished minuscules.

10
Roman Letters With and Without Serifs, and Their Joining

———————◆———————

Materials

Lined notebook paper
Red and black nylon tip pens
Quarter-inch cross-sectioned ruled graph paper (8½ by 11 inches)
Draftsman's pencil and sharpener
Ruler
Calligraphic pen holder and nibs
Black India ink
File folder

Once basic fine lettering in black has been mastered, the arts of illumination and layout (design) naturally follow. Some definitions are necessary.

Rubrication—The addition of colored (generally red) letters, line finishings, or ornamental designs to a black-lettered manuscript.

Illumination—The decoration of writing in color or gold.

Gilding—The illumination of a manuscript with gold leaf or with gold leaf and colors. The use of gold paint is not gilding.

Ornamentation—The use of one decorated Roman letter, drawn much larger than the text, illuminated, and used as the first letter of a block of text.

We are not going to concern ourselves in this book with gilding, which is an art in itself. We are, however, going to discuss ornamental and illuminated letters and rubricated and illuminated manuscripts.

The basic technique in ornamentation of letters is the addition of serifs. Mastery of serifs requires learning the correct proportions of each Roman letter. For this reason, return to Exercise 2 of the seventh chapter and do it again on quarter-inch cross-sectioned ruled graph paper before beginning the work in this section.

Exercise 1: Referring to Exercise 2 of the seventh chapter, use a black nylon tip pen to draw each letter in a ½-inch square on the graph paper, omitting the red "dashes" in the illustration here.

These red dashes are serifs. They are called left (or right) serifs when they extend from only one side of the stroke. Otherwise they are centered on the stroke.

Using a red nylon tip pen, add the serifs as shown here. Note that letter *W* has a left and a right serif as well as two centered serifs.

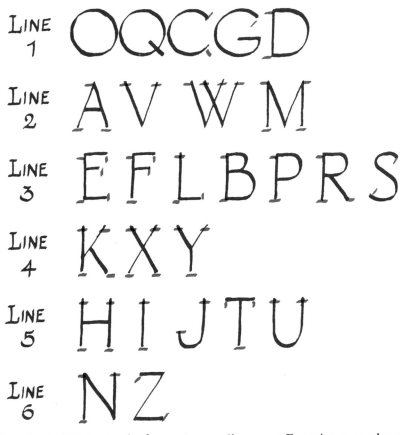

Exercise 2: With the draftsman's pencil, repeat Exercise 1 on the graph paper, keeping the paper in a vertical position. Then, using the 1-millimeter nib and black ink, go over the penciled letters, tilting the paper toward the left.

The serifs on the letters *B, D, E, F, L, P,* and *R* are drawn as part of the stroke. Other serifs are added *after* the letter is drawn.

Take your time. Some letters will prove more difficult than others. Repeat until you achieve fluency.

Exercise 3: With the draftsman's pencil, draw the letters as shown on your ruled notebook paper. Next, go over the penciled letters, using the 1-millimeter nib and black ink. You will see which letters are weak and need improvement. Practice them until they are right. Remember to change the position of the paper. The serifs, for example, would become too wide if drawn with the paper in a vertical position.

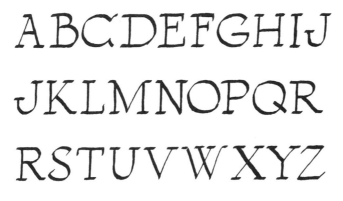

Exercise 4: Draw a pencil line ¼ inch above the base line to use as a guide while drawing smaller-size Roman letters.

For a decorative appearance, Roman letters must be drawn closely together. Because of the serifs, the counter system is not as useful as it usually is. Here you must learn to trust your eye and your feeling for the serif counter system. For example, to arrange the letters in the word *freely:* After drawing the letter *F,* draw the top left serif of the letter *R* first. Then draw the vertical stroke, and finish the letter *R* as you normally do. Since the widest point in letter *R* is the right serif on the base line, letter *E* must be begun by drawing the bottom left serif first. Then continue with the vertical stroke of letter *E* and finish it normally.

FREELY DRAWN ROMAN

LETTERS REFLECT ONE'S

PERSONALITY & TASTE.

When drawing over the penciled letters with the nib pen, begin each stroke in the letters as you normally do.

Proper spacing of Roman letters depends, of course, on proper placement of all serifs.

Exercise 5: Small-size Roman letters are arranged in the same manner as the large ones. Fewer serifs are used as letter size diminishes. This is a matter for your judgment. If the size of your letters is too small to draw well-formed serifs, leave them out.

ST. JOHN XIV.

GEORGE GORDON, LORD BYRON
1788~1824

AKRON CLUB OF LIONS INTERNATIONAL

11
Built-up Illuminated and Ornamental Letters

Materials

Lined notebook paper
Black and red nylon tip pens
Cross-sectioned ruled graph paper (8½ by 11 inches)
Crowquill Point Brause 66EF drawing pen
Pen holder (round)
Drafting paper
Draftsman's pencil and sharpener
Eraser
Ruler
Black India ink
Red drawing ink
Pen cleaner
Paintbrush (Grumbacher size 0000 or equivalent)
Enamel paint in gold, red, blue, and green
Paint remover (thinner)
File folder

In manuscripts, illuminated letters are drawn smaller than ornamental letters. This requires the use of a fine-point drawing pen, such as the Crowquill Point Brause 66EF. Skill in the use of fine-point drawing pens comes only with practice. Because of its flexible construction, the Crowquill 66EF pen makes a squeaking noise that sometimes startles people using it for the first time. With the drawing pen use a round pen holder.

The inexpensive cross-sectioned graph paper we have been using cannot be used with fine-point drawing pens. The fibers in the paper will feather and clog the pen point. High-quality drafting paper is necessary.

Good paintbrushes are also necessary; quality work simply cannot be done with a cheap brush. High-quality brushes by Grumbacher and others are readily available.

A good high-quality enamel is manufactured by the Testor Company. Testor's Pla Enamel in quarter-ounce bottles, normally used by model makers, is sold in a wide array of colors in variety stores. The bottle size is ideal and the enamel is quite inexpensive. When buying the enamel, be sure to buy several bottles of Testor's paint thinner, which you will need to clean your brushes.

Illumination is the decoration of letters with colors. It is one of the most satisfying facets of calligraphy. You already have discovered the beauty of calligraphic writing, and you will also find great satisfaction in the colorful art of illumination.

The letters in the following exercises are called *built-up letters*. A built-up letter, when filled in with color, becomes an illuminated letter. The filling-in will be discussed later.

Since all built-up letters, illuminated and ornamental, are drawn with a drawing pen that produces only fine lines, the paper is kept in a vertical position.

Exercise 1: Using a black nylon tip pen on cross-sectioned graph paper, draw Roman letters *without serifs* in ½-inch squares. Study the red build-up strokes carefully. Draw them (and the serifs) with a red nylon tip pen. Make sure the serifs are proportioned correctly. Follow the illustration carefully, and don't allow yourself to become careless.

When you think you have some proficiency, draw the letters entirely in black. Compare your built-up letters frequently with those of the illustration. Note that letters *I, M, N, S, T, Y,* and *Z* have strokes that are built up on both sides. After some practice you will be able to draw these letters as built-up letters without the intermediate step of adding strokes on both sides of strokes that are to be built up.

Some of the letters will be more difficult than others. Draw them over and over again until they are right.

Exercise 2: The counter system of illuminated letters is the same as for built-up Roman letters, using serifs.

With your draftsman's pencil sharpened to the finest point you can grind, first trace the letters between two lines of the ruled notebook paper. Then draw the letters freehand. Next, insert the drawing pen in the holder and carefully burn off the tip in the flame of a match. With black ink, draw over the penciled letters.

Exercise 1.

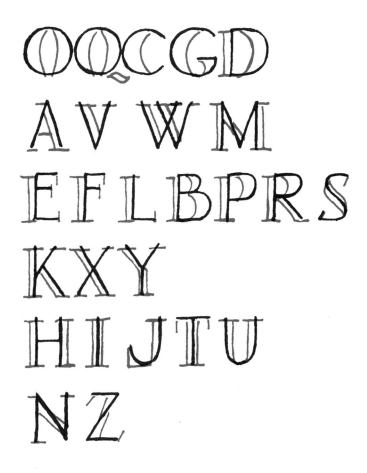

Exercise 2.

Exercise 3: Using drafting paper and the draftsman's pencil, trace only the black lines in each letter. Then go over them in black ink with the drawing pen. Next, add the serifs in red ink and fill them in as illustrated.

Take another sheet of drafting paper and lay it over the sheet of drafting paper on which you have traced the letters in black with red serifs. Keep the cross-sectioned paper under the black and red letters as a guide. With the draftsman's pencil, trace the letters as *completed* built-up letters. They should look exactly like those in Exercise 4 except for size and illumination.

Remove the drafting paper with the black and red letters, and go over the penciled letters with the drawing pen. Illuminated and ornamental letter strokes are always drawn in black only.

Compare your letters frequently with those of the illustration.

The fine black lines will show you how evenly you have drawn the width of the built-up letters. Keep the built-up letters well proportioned and draw the serifs correctly. In the beginning, if necessary, use the cross-sectioned paper under the drafting paper as a guide.

If you have trouble with a round or partly rounded letter, don't put too much emphasis on the outside line. The fault is usually in the inside shape of the letter: It may be too wide, or not wide enough.

Don't rush this exercise!

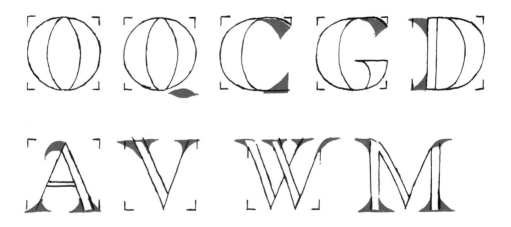

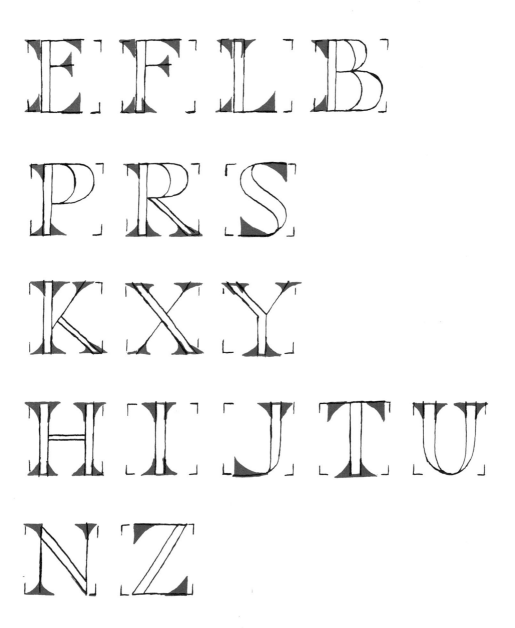

Exercises 4 and 5.

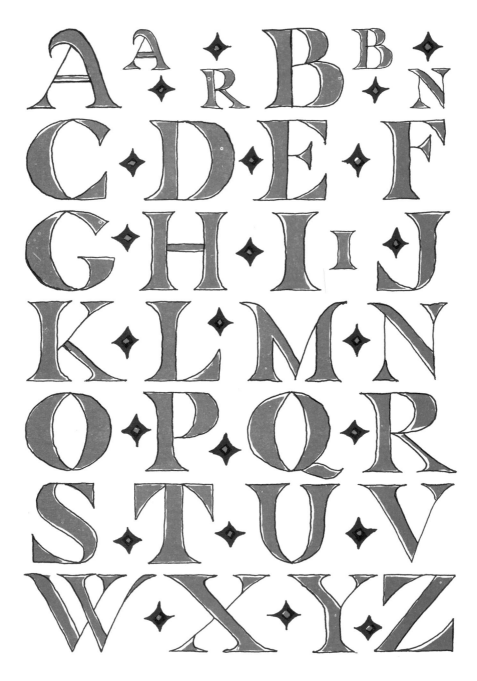

Exercise 4: Freehand ornamental letters can be drawn only after you have mastered Exercise 3. Don't begin this exercise until you have.

With the draftsman's pencil draw base and top lines $^{13}/_{16}$ inch wide on draftsman's paper. Then draw the alphabet freehand. After doing this to your satisfaction, ink in the lines with the drawing pen.

This is obviously more difficult than it sounds. Study each penciled stroke and letter carefully, and correct when necessary. Every good calligrapher examines the penciled work with an eye to improvement before inking in.

Exercise 5: In this exercise you will illuminate the alphabet you prepared in Exercise 4.

Take a bottle of enamel and shake it well. During your work, the bottle is placed (like the ink bottle) on the left side of your work area, off the drawing board. (The bottles of enamel should be tightly closed whenever they are not in use.)

Dip the paintbrush in the enamel and begin. Use only a very small amount of enamel on the brush, wiping the excess off on the mouth of the jar each time. Try various colors. At each color change, clean the brush with paint thinner, then dry the bristles with a paper towel.

After each work session, clean the brush with paint thinner and then with liquid dishwashing soap. Rinse it in running water. Before the brush is dry, gently mold the bristles into their original shape with your fingers. Store the brushes, bristles upward, in a jar.

Exercise 6: The larger the letter, the easier it is to illuminate. This exercise provides practice in illuminating smaller and more difficult letters. When you have developed some skill, try illuminating other words. Start with your own name, for example.

Some mistakes are to be expected. Some small mistakes may be corrected by redrawing the lines with the pen, but don't get into the habit of redrawing lines; get into the habit of illuminating correctly!

ILLUMINATED ROMAN LETTERS

12
Ornamental Designs and
Line Finishings

Materials

Lined notebook paper
Draftsman's pencil and sharpener
Ruler
Calligraphic pen holder and nibs
Black India ink
Drawing ink (various colors)
Pen cleaner
File folder

Ornamental designs placed within and next to the written text enrich the entire manuscript and give it charm. Some calligraphers use a great deal of ornamental design, taking months, in some cases even years, to complete a manuscript. Sometimes ornamental designs incorporate flowers and leaves so small that they can hardly be seen. Mastery of illuminated ornamental design takes years of study and practice. As a beginning calligrapher, however, you can learn the fundamentals of ornamental design. Even the simplest ornamental design, if done correctly, will add beauty to your manuscript.

Ornamental designs are used in different ways. Depending on the style of a particular manuscript, ornamentation may be needed only on the left margin or only on the bottom, or it may form a complete frame. (A complete frame—a design drawn around all four sides of the text—should be attempted only after a great many smaller designs have been completed satisfactorily.)

Once the basic ornamental design examples given here have been learned, you may experiment by expanding a design, either by modifying the shape of the basic design or by using multiples of it.

When ornamental designs are used to fill (or "kill") white areas at

the end of a line, they are called *line finishings* and are drawn with the same size nib used to draw the text.

If you have trouble with a particular design while practicing the exercises, trace it first with the draftsman's pencil, then go over it with the nib pen.

Exercise 1: Trace the designs using a 2-millimeter nib and black ink on ruled notebook paper. Note that the dots form a diamond. Dot 1 is the point of reference for all other dots and is drawn in the center of the ruled line. Dot 2 is drawn at the upper point of the diamond, Dot 3 at the lower point of the diamond, and Dot 4 directly across from Dot 1.

Trace them until they are right. Then practice drawing them freehand. Remember the sequence.

Exercise 2: Begin the horizontal stroke on top of the ruled line, drop it slightly below the line, and end it on the ruled line again.

Exercise 3: Begin the horizontal stroke below the ruled line, keep the middle part straight on the ruled line, and end it above the line. Note the drawing sequence of the three dots.

Exercise 4: In this exercise all dots touch one another. Draw a single line of dots on the ruled line first. Then draw the dots above the line, and finally the dots below it. (In a religious text, when the dots form a cross, they should be drawn in purple or red.)

Exercise 5: The strokes on the top row are drawn on the ruled line; the strokes on the second row are between and below the top strokes.

Exercise 6: With the draftsman's pencil, draw guide lines ⅛ inch above and below the ruled line on the notebook paper. The strokes begin just below the upper guide line, rise slightly to touch it, and then drop through the ruled line to barely touch the bottom guide line. The dots are drawn last.

Exercise 7: With the draftsman's pencil, draw a guide line ¼ inch above the ruled line. Stroke 1 is continuous. Draw Stroke 2 within the white areas above the base line; it rises from and then returns to the base line. Finally, draw the dots, which touch the guide line.

Exercise 8: With the draftsman's pencil, draw guide lines ⅛ inch above and below the ruled line on the notebook paper. Draw Stroke 1 from the upper guide line through the ruled line to the bottom guide line. Stroke 2 begins on the bottom guide line and rises to touch the upper guide line. Both strokes are drawn as continuous lines, and the dots are added afterward.

THE LORD is my Shepherd: I shall not want. He maketh me to lie down in green pastures: He leadeth me beside the still waters. He restoreth my soul: He leadeth me in the paths of righteousness for His Name's sake. Yea, though I walk through the valley of the shadow of death, I will fear no evil: for Thou art with me; Thy rod and Thy staff they comfort me. Thou preparest a table before me in the presence of mine enemies: Thou anointest my head with oil; my cup runneth over. Surely goodness and mercy shall follow me all the days of my life: and I will dwell in the house of the LORD for ever. Psalm 23

Plate VI: Twenty-third Psalm; 17 by 14 inches; gold, red, blue, green, and purple. This manuscript will give you the opportunity to use a large ornamental letter, *T* (2¼ by 2 inches), framed in a 2½-inch square.

After illuminating the ornamental *T,* scatter border design figures inside the ornamental letter square. Illuminate the word *Lord* in gold only.

If the phrase "In Loving Memory of (Name)" is added, the manuscript becomes a memorial.

Exercise 9: The left end of the design is slightly below the ruled line; the right end is slightly above it.

Exercise 10: Follow the arrows. Keep the design centered on the ruled line.

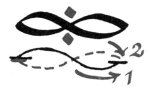

Exercise 11: Follow the numbered strokes and arrows carefully. This design will take more practice.

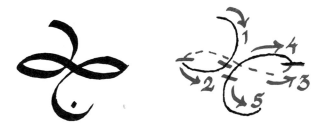

Exercise 12: After you have mastered all the ornamental designs, draw them again using colored ink.

13
Paragraphing and Versals

In early books (early manuscripts as well as printed books) the text was seldom divided. Often there were no chapters or paragraphs, at least as we know them today; words simply followed each other down the page and from page to page. It was up to the reader to determine where one line of thought ended and another began.

Divisions within a text were, of course, as necessary then as they are now, and gradually calligraphers developed methods to accomplish this. The first paragraph division was simply a break in the text (an extra space). Next came a simple mark in addition to the extra space.

When minuscule letters came into use (probably to conserve space), majuscules lent themselves naturally to the first letter (or word) in what we now call a paragraph. It was from this use of majuscules to set off the first letter, word, or words of a manuscript that illuminated letters and words evolved.

The word *versal* came into use at this time. A versal is a word drawn with an illuminated or Roman first letter, and finished with Formal Script letters to set it off from the flourished italics of the body of the manuscript.

One test of a well-done manuscript is the absence of blank ("white") areas. The whole manuscript gives the appearance of completeness and fullness. To achieve this look of completeness, the calligrapher uses versals to join two or more paragraphs into one visually solid block of text. The different writing style used for the versal signals to the reader the beginning of a new thought or subject in the text.

This is an area where the calligrapher must consider both the visual appearance and the meaning of the manuscript. As a general rule, it is better to draw as many as three or four short words in Formal Script as a versal rather than lose reader comprehension. If a versal has only one or two letters, the following word is drawn in Formal Script.

THE✦OATH✦OF✦HIPPOCRATES

I swear✦by✦Apollo✦the✦Physician,✦and Aesculapius✦and✦Health,✦&✦all,✦Heal, and all the Gods & Goddesses, that according to my ability & judgement, I will keep this Oath & this Stipulation

To reckon him who taught me this Art equally dear to me as my parents, to share my substance with him & relieve his necessities if required; to look upon his offspring in the same footing as my own brothers & to teach them this Art if they shall wish to learn it, Without Fee or Stipulation,& that by precept. lecture,& every other mode of instruction, I will impart a knowledge of the Art to my own sons, & these of my teachers,& to disciples bound by a Stipulation & Oath according to the Law of Medicine, but to none others.✦ I will follow that system of regimen which, according to my ability & jugdement, I consider for the Benefit of my Patients, & abstain from whatever is deleterious & mischievous. ✦ I will give no deadly medicine to anyone if asked, nor suggest any such counsil: & in like manner I will not give a woman a pessary to produce abortion. ✦✦With Purity & with Holiness I will pass my Life & Practice my Art.✦ I will not cut persons laboring under the stone, but will leave this to be done by men who are ✦ practitioners of this work.✦Into whatever houses I enter, I will go into them for the Benefit of the Sick,& will abstain from every voluntary act of mischief & corruption,& further from the seduction of females, or males of freemen & slaves,whatever in connection with my professional practice, or not in connection with it. I see or hear in the life of men, which ought not to be spoken of abroad, I will not Divulge as reckoning that all such should be kept secret.✦While I continue to keep this Oath unviolated, may it be granted to me to enjoy Life & the Practice of the Art respected by all men, ✦ in all times, but should I trespass & violate this Oath, may the reverse be my lot.

Plate VII: Oath of Hippocrates; 16 by 19 inches; gold, blue, green, and red. This manuscript has a large illuminated letter and contains more words than any of the others.

THE•OATH•O

 swear•by•A
Aesculapius
and all the Gods
ability & judgement,

To reckon him who taught me this
my substance with him & relieve his nece
the same footing as my own brothers & to
it, Without Fee or Stipulation;& that by
I will impart a knowledge of the Art to

Plate VIII: Detail of Oath of Hippocrates manuscript.

Versals are usually used to begin otherwise undifferentiated paragraphs in a block of flourished black writing, both to conserve space and to achieve a look of harmony. They may also be used to stress an important word, and—in shorter manuscripts—to stretch the text.

The ''Oath of Hippocrates''manuscript (Plate VII) shows how versals are used. The ''L. Howard Carter'' manuscript (Plate IX) demonstrates one purpose of versals (emphasizing a significant word in the text), although *Whereas* and *Resolved* are not technically versals.

While versals (or words set off like versals) are used for several purposes, their most important function may well be the way in which they enrich a manuscript by their placement and with their colors. They give a certain elegance and dignity to a manuscript.

The Formal Script following the first letter of a versal is usually drawn in black, but sometimes it is desirable to use color. In this case, a different color must be used for the illuminated or Roman first letter of the versal. All versals within a manuscript should be drawn in the same style and color(s).

Versals may often be used in conjunction with line finishings. Particularly in lengthy manuscripts, the use of versals with line finishings helps the eye to locate breaks in the text and at the same time helps to beautify the manuscript.

In the "Oath of Hippocrates" manuscript, the diamond is the ornamentation used. The diamond is drawn with the draftsman's pencil first, then drawn over with the drawing pen, and illuminated last.

14
Colors in Calligraphy

The theory of color is a complex subject beyond the scope of this book. However, a practical understanding of color and how it is used can be gained by studying the manuscripts of both ancient and present-day calligraphers and by experimenting in your own work.

Dominant Colors

For a pleasing and elegant appearance, *one* contrasting color (gold is not considered a color) should be dominant against the massed black flourished writing. For example, in the original "L. Howard Carter" manuscript red is the dominant color. Too many colors not only distract attention from the meaning of the text but also destroy the look of harmony in a manuscript. Avoid aggressive or clashing colors: Yellow does not go with gold, and orange does not harmonize with red.

Names in Color

Names written in large letters (such as *Lion L. Howard Carter* in the Carter manuscript) should always be illuminated in gold.

Toning Down Ornamental Letters

The amount of gold necessary to illuminate certain large letters sometimes gives the letters an undesirably plump look. If this happens, the letter may be toned down by outlining the letter just *inside* its border and filling in the narrow space between the outline and the border with another color. For example, dark blue is generally the most effective toning-down color to use with gold.

Color Arrangement for Headlines, Titles, and Massed Black Writing

Like the breaking of the text, color should be used not only to enhance the appearance of the page but also to increase the reader's awareness of the meaning of the text.

Red is the brightest and most striking color and should be used to catch the eye. The headline (first line of text) of the original "Oath of Hippocrates" manuscript contains a number of red illuminated letters.

The text of this manuscript is such that an extraordinarily long headline was necessary. Small ornamental designs placed between the words serve to kill excess white areas and help to decorate the manuscript. When space in a line is limited, small ornamental designs may still be used, in this case solely for decoration.

Colors used in the title (the line at or near the top of a manuscript announcing its subject) should blend in well with the colors in the rest of the manuscript. In the "Oath of Hippocrates" manuscript I used blue because of the many red and green illuminated letters in the text. In other words, a richly illuminated manuscript should be toned down with a dark (black or blue) title.

If red is not used elsewhere in a manuscript, it may be used for the title.

When using more than one color (plus gold) within massed black writing in a manuscript, any color may be chosen *except* the color used in the headline. (Dark blue, however, does not show up well and can rarely be used.)

In a manuscript having a large area of massed black flourished writing, such as the "Oath of Hippocrates" manuscript, it is sometimes necessary to emphasize certain letters in gold within the massed black writing. In this example, illuminating the word *I* in gold is appropriate to the sense of the text.

Color in Formal Script or Roman Letters

Manuscripts in Formal Script or Roman letters only should be drawn using color very carefully. No more than two colors (plus gold) should be used; otherwise the manuscript loses its grace.

Drawing Ink Colors

Colored drawing ink tends to flow more readily through the pen than black India ink. For this reason it is best to put less colored ink in the reservoir.

If you want to tone down bright colors like red and green, experiment by adding black ink, one drop at a time, to the bottle of colored ink. Shake the bottle well and experiment with the toned-down color until it looks right to you. Yellow mixed with black, for example, looks like gold.

Color in Ornamental Designs

The proper use of color in ornamental designs is as delicate an art as using colors for illuminated letters and Formal Script. Do not overcrowd a manuscript with too many colored ornamental designs.

If your manuscript is already rich in colors, or you cannot decide which color(s) to choose for ornamental designs and line finishings, use black. Black is the safest and most appealing color. In any event, *always* use some black with colored ornamental designs and line finishings.

15

Basic Layout, Skeleton,
Final Draft, and Color Testing

Materials

Adhezo-tack
Lined notebook paper
Black and red nylon tip pens
Drafting paper
Draftsman's pencil and sharpener
Soft eraser
Guide sheets No. 1 and No. 2
Ruler
Scissors
Calligraphic pen holder and nibs
Round pen holder and drawing pen
Pen cleaner
Black India ink
Colored drawing ink (various colors)
Paintbrush
Enamel paint (various colors)
Paint remover

Adhezo-tack is the trade name of a claylike material sold by the Milton Bradley Company, Springfield, Massachusetts 01107, and readily available in office supply stores. A pinhead-size dab of this material permits pieces of paper to be temporarily stuck together and then to be easily separated with absolutely no damage to the paper. It is a great help in arranging the parts of the draft manuscript and is vastly superior to rubber cement and other adhesives for this purpose.

A sculptor was once asked how he converted a block of granite into the form of a beautiful woman.

"Simple," he replied. "I just chip away anything that doesn't look like a woman."

It is as difficult to tell someone how to make a beautiful manuscript as it is to tell someone how to carve a beautiful statue. However, just as the sculptor has hammers and chisels, so the calligrapher has the help of special tools and techniques. The most important tool of both is the eye. Beginning calligraphers must learn to use this valuable tool exactly as they learned to master their pens and brushes. The best way to do this is to study the work of master calligraphers, looking at the work not so much for its beauty but in an attempt to understand how that beauty was achieved.

Examples of the work of master calligraphers can be found in most libraries. If your library does not have them, your librarian will probably be more than happy to get books on calligraphy from larger libraries on interlibrary loan.

Another good way to sharpen your eye is to study layout wherever you see it, whether in a magazine, on a billboard or book jacket, or anywhere else. You will soon find yourself picking out those items that catch and hold the eye of the viewer. You will probably be surprised at how quickly you develop an eye that can differentiate between good layout and bad. Frankly, until you can do this, the practical techniques that follow will be useless.

As you have studied the basics of calligraphy, you have already begun to develop your eye. By now you are able to see how the calligrapher can give greater beauty to a work than the most accomplished printer. No matter how artistic printers are, they are forced to work with type. The calligrapher has no such restriction.

Every manuscript poses different problems, the solutions to which come far more from experience, taste, and judgment than from following a set of rules.

Plate IX is the "L. Howard Carter" manuscript. This is a commissioned calligraphic work that I prepared for a chapter of Lions International. It represents many hours of thought and work.

Since there is no substitute for experience, you are now going to acquire some experience by duplicating this calligraphic scroll step by step. As you proceed through the various steps, you will see how I solved the problems that came up. Obviously there are other—possibly better—solutions, and you will certainly see things you would have done differently. However, you are to copy each step exactly. If nothing else, this will point out the difference in personal tastes.

I received the following text from the president of the Lions Club, with his instructions to use my judgment in making an attractive scroll to honor a faithful, longtime Lion. (I have changed the names.)

Whereas, Lion L. Howard Carter has served with distinction as a Charter Member of the Akron Club of Lions International since 1925, and whereas, Lionism has prospered greatly from the exemplary unselfish service and dedication of Lion Carter, now therefore be it resolved that the Akron Club of Lions International in honor and grateful appreciation thereof, hereby designates Lion L. Howard Carter as a Life Member of the Club, with all the rights and privileges pertaining thereto.

Done by resolution unanimously adopted this 11th day of July 1975.

Attest: Thos. G. Winslow, Secretary, Richard J. Russell, President, Akron Club of Lions International.

The Basic Layout

1. Copy the text with a black nylon tip pen in your regular handwriting on ruled notebook paper. This will give you your first rough idea of how much text you have to work with.

Since you will be drawing the manuscript in a longer-than-wide (oblong) shape, keep this in mind as you go over the handwritten copy, marking probable line breaks in the text with a red nylon tip pen. Then read it again to make sure that in your visual breakdown you have not caused awkward breaks at the ends of some lines. If necessary, go back and rearrange the line breaks.

I broke down the text as shown in Plate IX, based on my determination of what would both reflect the meaning of the text and please the eye.

2. Seeing the text written out should give you a good idea of what sort of lettering is most appropriate, based on physical considerations and the meaning of the manuscript.

With the red nylon tip pen underline each word that will be set off in some manner from the massed black flourished text of the manuscript.

3. Now go over the underlined words and decide which letters are to be ornamental, illuminated, Roman, or some combination of these. Draw a red box around these letters and words.

4. Take a sheet of drafting paper and place guide sheet No. 1 underneath it. With the draftsman's pencil, draw the text again, omitting letters and words that are to be given special treatment. Break it into lines as indicated, and use the size and writing style in which it will appear on the finished manuscript. Begin each line on the left edge of the drafting paper. Where your first handwritten copy of the text indicates an illuminated and/or Roman letter, sketch the letter in roughly. Where the handwritten text indicates a versal, draw the word in Formal Script.

It may be necessary to rearrange the line breaks once again. The emphasis here should be not only on the arrangement of words and sentences, illuminated letters, and Formal Script, but also on the writing itself. In other words, each style must be drawn perfectly from the beginning as it will appear in the final work.

5. With scissors, cut what will become the massed black flourished text from the drafting paper.

For the Carter manuscript I used 11 by 14-inch drawing paper. I began the massed black text with the words has served, *and finished it with* pertaining thereto. *Because I decided to draw the first letter in each* Whereas, *the* Resolved, *and the* Done *large and illuminated, I left these first letters out of the massed flourished text and started on the left margin with the Formal Script only.*

6. Draw the headlines and titles (normally the ornate words and phrases of the manuscript) on drafting paper and cut them out.

I drew the first Whereas *as the title, making its* W *and Formal Script slightly larger than the second* Whereas. *For the very important words* Lion L. Howard Carter *near the top of the manuscript, I chose elaborate, built-up Roman letters.*

The significant words Lionism, Lion, Life Member, *and the name* L. Howard Carter *were emphasized with small illuminated letters, Formal Script, and Roman letters with serifs.*

Whereas,

LION L. HOWARD CARTER

has served with distinction as a Charter Member of the Akron Club of Lions International since 1925, &

Whereas, Lionism has prospered greatly from the exemplary unselfish service & dedication of Lion Carter now therefore be it ∞:

Resolved that the Akron Club of Lions International in honor & grateful appreciation thereof, hereby designates Lion L. Howard Carter as a LIFE MEMBER of the Club, with all the rights and privileges pertaining thereto. ∞

Done by resolution unanimously adopted this 11th day of July 1975

Attest:

THOS. G. WINSLOW
SECRETARY

RICHARD J. RUSSELL
PRESIDENT
AKRON CLUB OF
LIONS INTERNATIONAL

Plate IX: L. Howard Carter; 14 by 11 inches; gold, red, green, and blue. Every step in the preparation of this manuscript is explained in detail.

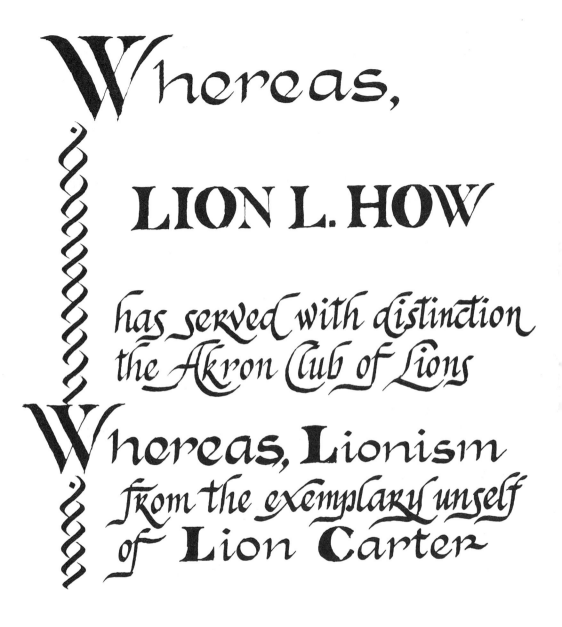

Whereas,

LION L. HOW

has served with distinction the Akron Club of Lions

Whereas, Lionism from the exemplary unself of Lion Carter

Plate X: Detail of L. Howard Carter manuscript.

7. Arranging the cut-outs on the drafting board will give you an indication of the size of the finished manuscript. To "stretch" or "shrink" the manuscript you may find it necessary to redraw the massed black flourished text, using a different-size guide sheet.

Because the Carter manuscript contains relatively few words, I used the ½-inch-wide guide sheet. In emphasizing the second Whereas *and the word* Resolved, *I divided the massed flourished text into three parts. At the same time, I "stretched" the manuscript to achieve a degree of harmony among the three large illuminated letters, which otherwise might have been jammed too close together.*

8. To determine the proper nib size for the manuscript, draw over several words of the penciled draft of the massed black flourished text, using different nib sizes. In general, a nib size ½ millimeter larger than that selected for the massed black flourished text is about right for the Formal Script of the versals.

9. In a similar manner select the nib size to be used for the headline. A nib size ½ millimeter larger than that selected for the Formal Script of the versals would be a good choice. On the draft, write each nib size above the part of the text for which it has been chosen.

When using the ½-inch-wide guide sheet, I never choose a nib size less than 1½ millimeters for the massed flourished text and the Formal Script within the flourished text.

Because the first Whereas *stands by itself like a title, I drew it slightly larger than the other* Whereas, *using a 2-millimeter nib size. (To give it a heavier appearance, use a 2½-millimeter nib.) Thus I could emphasize, or introduce, the important words* Lion L. Howard Carter.

For the title (Lion), *name* (Carter *and* L. Howard Carter), *and the words* Lionism *and* Life Member *within the black flourished text, I used a 1½-millimeter nib.*

10. Lay out the drafts on the drawing board and use your eye to determine the size of the ornamental letter. With a draftsman's pencil, roughly sketch the letter to size, and lay it out with the other pieces. It may be necessary to draft ornamental letters of three or four different sizes before you hit upon the one that harmonizes with the whole.

At first, I drew the W *in the first* Whereas *as an ornamental letter, and the* W *in the second* Whereas *and the* R *in* Resolved *as illuminated letters. When I studied the draft of this possible solution, however, I realized that the text would be better served by using ornamental letters (drawn slightly smaller than normal, and without gold illumination) at the beginning of each versal word.*

Then I saw that this solution to the problem resulted in a somewhat unbalanced manuscript. The upper half of the text had three large letters on the left margin, and there was too much white area on the lower left half of the manuscript. I solved this problem by drawing the first letter of the line giving the date (the D *in* Done) *large, like the* W *and the* R. *I postponed a decision on how to handle the rest of the line.*

The Skeleton

11. The skeleton is a sheet of blank drafting paper used for the arrangement of the components of the manuscript. Draw a vertical pencil line down the center of the drafting paper and another line horizontally through the middle to provide visual centering references. Locate and mark the center of the first line of the massed flourished writing. Slide the massed black flourished text under the skeleton, aligning the mark with the vertical reference line to give you an initial impression of how well the text naturally centers itself. Using the centering lines of the skeleton as reference points, decide where you are going to place the margins. Taking into consideration the shape, size, and context of the massed black flourished text, select the arrangement that most pleases the eye and mind.

Do not do this hastily, and try several variations before making your decision. Proper placement and arrangement of the massed black flourished text is the most important task of manuscript layout.

I decided that the Carter manuscript required an 11 by 14-inch sheet of paper. In reaching this decision, I had to judge the amount of white area needed for the headline and title at the top of the manuscript, and for the date and names on the bottom.

12. Slide *Lion L. Howard Carter* under the skeleton. If it is wider than the lines of black flourished text that follow, you will have to decrease the space between the words and/or draw smaller letters.

13. The ornamental letter must harmonize with the headline in the text. Slide the ornamental letter under the skeleton and move it around until balance is achieved. Normally, the ornamental letter should extend an equal distance above and below the Formal Script that follows.

Change the size of the ornamental letter until it pleases your eye. Then draw it properly and mark its position on the skeleton.

14. Locate and mark the center of the title (or other significant wording). Slide it under the skeleton so that the center mark touches the vertical line of the skeleton.

Move all the other component pieces around under the skeleton until you think they are properly arranged. Put small bits of Adhezo-tack on each cut-out and fix it in place under the skeleton. Some final adjustment will be necessary later, but fixing the cut-outs in place now will make final skeleton preparation easier.

I measured and marked the center of the title Lion L. Howard Carter, *and moved it up and down between the upper* Whereas *and the first line of black flourished writing until I was pleased with its placement.*

15. Now is the time to decide whether you want to use a versal in the date line near the bottom. As a rule, the date should be drawn with a nib size ½ millimeter smaller than that used for the massed flourished text.

Draw the line containing the date with the draftsman's pencil on a separate piece of paper and slide it under the skeleton, placing the first letter of the first word on the left margin.

I broke the date line into two short lines, which both looked better and provided more white area for the signature of the president of the Akron Lions Club. Both lines of the date text were drawn with a 1-millimeter nib. The Arabic numerals were drawn with a 1½-millimeter nib.

16. With all the cut-outs fixed in place in front of you, you can now decide on the size of the small letters to be used for the text below the date.

Draw these small-size words with the draftsman's pencil on a separate piece of paper and slide it under the skeleton.

The president's name on the right margin should be placed slightly higher than the secretary's name on the left margin.

The word Attest *was done at first in Roman letters with serifs, using black ink. Then I decided to draw it with the first letter illuminated and the rest in Formal Script so that it would accord with the large initial letters of each* Whereas, *the* Resolved, *and the* Done, *and with the Formal Script letters that complete these words. I used a 1 ½-millimeter nib.*

The names Thos. G. Winslow *and* Richard J. Russell *were easily drawn with serifs, using a ¾-millimeter nib. I used a drawing pen for the remaining words, which were given smaller Roman letters without serifs.*

17. If you have found it will be necessary to use line finishings, or if you wish to draw an ornamental design around the text (perhaps you plan to use both), select one or more designs you like. Remember, these decorations are used as both ornamental designs and line finishings.

I chose the same design for line finishings as I used for the border design, because I thought that one design used on both the right and the left margins would be most pleasing to the eye.

18. Measure on the skeleton the length of the ornamental design(s) and draw it on drafting paper. Then go over the design(s) in black ink with the nib. Cut the design(s) out and slide it under the skeleton.

Be careful not to put ornamental designs too close to the text; this will destroy the graceful appearance of the whole manuscript. Again, move the design(s) back and forth until your eye tells you it is correctly placed.

If you have a number of line finishings on the right margin, you may wish to move some of them to the left margin for greater symmetry. To do this, shift the lines of text so that they end on the right margin, and place the line finishings at the beginning of the line.

Mark the proper nib size above the ornamental design(s) and line finishings on your cut-out pieces.

19. When you have arranged all the component pieces under the skeleton to their best advantage, mark their locations with short lines drawn with the pencil on the skeleton at the left and right margins. Then remove the pieces.

I used the second Whereas *as the reference point in positioning the two other significant words below it, and for the placement of the border design. I drew a*

vertical line on the skeleton from the center of the W *to the top and bottom of the page, and used it to align the first letter of* Resolved *and* Done, *and to correctly position the border design.*

20. Next, draw pencil lines across the page, using the marks as guides.

While the lines can, of course, be drawn with a T-square, I found it more precise to measure and re-mark the corresponding marks on the left and right margins, and then draw horizontal lines between them.

The result was a skeleton with the following cut-out pieces underneath:

- *The headline*
- *Three large ornamental letters beginning words drawn in Formal Script*
- *Mr. Carter's name drawn in Roman ornamental built-up letters*
- *The massed black flourished text drawn in three blocks*
- *Certain letters and words within the massed text designated for emphasis with small illuminated letters, Formal Script, and Roman lettering with serifs*
- *The line containing the date, drawn somewhat smaller than the massed text*
- *The signature blocks drawn in yet another style and size*
- *A simple style of line finishings and border design*

The Final Draft

21. One at a time, starting at the top, restore the component cut-outs under the skeleton and make the final drafts with the draftsman's pencil. This time draw in everything, including the ornamental and illuminated letters, the line finishings, and the ornamental design.

Ornamental designs and line finishings must be drawn in a perfectly straight line. Do not draw them freehand. Measure and draw with the draftsman's pencil the base and guide lines on the final draft. Then trace the design(s) from the cut-out piece(s) onto the final draft.

When you are finished, you should have a pencil version of the finished manuscript.

22. Mark the nib size to be used for the flourished writing over the first flourished word in the text. Then write the appropriate nib size over *each word* that will be drawn with a nib size different from the one

used for the massed flourished text, and draw a dotted line under each of these words.

2 3. With the final pencil draft before you, line up your colors on the work table and make the final decisions about the colors you will use. First, decide what color you want for the Formal Script. Then, *in the following order,* choose the colors for:
- Ornamental letter
- Illuminated letters
- Roman letters
- Ornamental designs and line finishings

Take your time when doing this. Make your decisions based on what the whole manuscript will look like, rather than on one part of it.

Electric lighting may play tricks on your eye when you are choosing a color scheme. Select colors in daylight only.

Color Testing

24. When you have selected the colors you wish to use for the various components of the manuscript:
- Select the appropriate ink color and ink in on the skeleton part of the title, headline, versal, Formal Script, and Roman letters.
- Color the ornamental letter, and a few of the illuminated letters, with a brush.
- Apply color to two or three inches of the ornamental design, and to one or two line finishings.

I illuminated the first letter of the manuscript, W, *with green ink. I used red to illuminate the first letters of the name within the massed text, and the first letter of the word* Attest. *I thought this helped give a well-balanced look to the other three large ornamental letters on the left margin, which were also illuminated in red.*

For the first letter of the significant words Lionism, Lion, *and* Life Member, *I used gold so that these letters would harmonize well with the larger illuminated gold letters of* Lion L. Howard Carter. *The Formal Script of* Lionism, Lion, *and* Lion L. Howard Carter *was drawn green, and for* Life Member *I used red.*

After using red to draw the year 1925 *and the day and year of the date at the bottom (*11, 1975*), I saw that there was too much red, so I changed the color here to green.*

To tone down the brightness of the large red areas of the three ornamental letters, I used blue for the line finishings and border design.

25. For the final manuscript prepare reference marks with a black nylon tip pen on the draft. These are crosses on the vertical dividing line, near the top, middle, and bottom.

26. Put the draft away for a couple of days! You have been entirely too close to it while preparing it to really be able to see it.

The techniques of preparing the basic layout, skeleton, and final draft apply equally to the simplest manuscripts and the most difficult ones. Smaller, simpler manuscripts, of course, require a less complicated organization, but as you progress from small, uncomplicated manuscripts to more complex works you will see how the foregoing procedures and techniques will enable you to complete a manuscript with confidence and little wasted effort.

If you have to discard a defective skeleton and make a new one, do not be disappointed. The fact that you can find fault with your own work shows that you have acquired the understanding that comes only from experience in drawing manuscripts, and layout will gradually become less difficult.

16
The Manuscript

Materials

Draftsman's pencil and sharpener
Soft eraser
Ruler
Adhezo-tack
Scissors
Calligraphic pen holder and nibs
Round pen holder and drawing pen
Pen cleaner
Black India ink
Colored drawing ink (various colors)
Paintbrush
Enamel paint (various colors)
Paint remover
Liquid dish soap
Mottled Parchain paper
Eberhard Faber Stenorace No. 1507 eraser
Pencil sharpener
Black poster board

Although even today much calligraphy is still drawn on genuine parchment, "the real thing" is a highly expensive material and difficult to work with. It requires great skill and much experience on the part of the calligrapher to take advantage of its special qualities.

Fortunately, there are several kinds of paper available that give the appearance of parchment but are far easier to use and quite inexpensive. The Paterson Parchment Company of Bristol, Pennsylvania, makes a paper called Mottled Parchain which I have found to be wholly satisfactory. When Mottled Parchain is placed above a sheet of bright yellow paper, the mottled characteristics of the paper are brought out, and colors drawn on the translucent paper seem to become richer.

Mottled Parchain has two textures: It is rough on one side and smooth on the other. The difference can be seen but not felt. Mottled Parchain paper can be found in well-equipped art supply stores, and most quality printers have stocks of it.

Removing ink from this tough paper requires a more abrasive eraser than the ones we have been using. The Eberhard Faber Stenorace No. 1507 eraser, which is shaped and sharpened like a pencil, solves the problem.

The frame and mat in which a manuscript is mounted are part of the overall appearance of the manuscript. It is important at this time to get an idea of what the manuscript will look like after it has been properly framed. A mock frame placed around the final draft (and your imagination) should give you a good idea of what the finished manuscript will look like, even though the final draft has colors only here and there.

Make a mock frame by cutting four 1½-inch strips from black poster board. Place them around the draft, and move them around until you obtain a pleasing appearance.

Study the draft carefully for inconsistencies of layout and color. This is your last chance to make changes. You may wish, for example, to try other colors at this time.

Mottled Parchain paper provides a different and somewhat more difficult working surface than drafting paper. The *smooth* side should be used. Before attempting to ink in the final manuscript, take a piece of Parchain and *carefully* practice a few lines of text with various nib sizes.

Manuscript Completion

1. Cut a sheet of Mottled Parchain somewhat larger than your finished manuscript will be. The margins may be reduced easily after you are finished. Remember to keep the paper free of finger marks and smudges by using a protective sheet under your hand when you are working.

2. Locate the center of the Parchain paper by measuring. Then draw a vertical pencil line down the middle from the top to the bottom, and a horizontal line through the center.

3. Place the Parchain paper over the draft, aligning the vertical and horizontal lines. With the draftsman's pencil trace the crossmarks from the.draft onto the Parchain paper. The alignment of the crosses

will insure a precise copy of the draft; refer to them constantly as you complete the manuscript. (For better visibility, you may put a sheet of white paper under the draft.)

4. Using pinhead-size pieces of Adhezo-tack on all four corners of the Parchain paper, attach the Parchain to the draft, making sure the crosses are properly aligned.

5. Locate the left and right margins, and mark both by drawing vertical lines with the draftsman's pencil and ruler.

6. Locate and draw all horizontal lines. Above each base line, draw a waist line that conforms to the measurements of the letters that will be drawn on that line. These will serve as guide lines, making it easier to draw the letters evenly.

7. With the draftsman's pencil trace everything on the final draft onto the Parchain paper. *Exercise as much care while drawing with the pencil as you will when drawing with ink.*

8. Refer to the draft and draw a dotted pencil line on the final manuscript under all words that will be drawn with a nib size different from the one used for the massed flourished style. Pencil in the appropriate nib size over each underlined word.

9. Take the draft off the drawing board. Place it where you can see it clearly, and begin to draw the massed black flourished text on the Parchain paper. Watch for the underlined words! Unless you are careful, you are liable to be halfway through a versal, name, or date before you realize that it should not be drawn with the nib size and color you are using.

10. After checking the draft for the proper color, draw the Formal Script, then the Roman letters, and finally the Arabic numerals.

11. With the fine drawing pen and black ink, draw the outlines of the letters to be illuminated. Make constant use of the reference crosses as you do this.

12. Illuminate the letters. Be sure to use the right color. Work with gold in daylight only; in artificial light you may miss white areas in the letter.

13. When you are finished with all the illuminated letters, go over the manuscript and examine all the ornamental and illuminated letters. If you have failed to fill in all the white area of a letter, fill it in now. If you have strayed slightly from the drawing pen outline, correct this by redrawing the pen line. Letters illuminated in gold should always be drawn over a second time to give them a richer appearance.

14. With the draftsman's pencil trace the line finishings and ornamental designs. Now that most of the manuscript has been colored, you may well decide that additional color is not needed, or indeed would be inappropriate. Examine the whole manuscript and decide whether the line finishings and the ornamental designs should be completed in black or in color. Then do so.

15. *No sooner* than twenty-four hours after the last color has been applied, erase the pencil marks and lines with a *soft* eraser (*not* with the Eberhard Faber Stenorace No. 1507).

16. Using the mock frame, decide how much (if any) of the margins should be trimmed. There should always be at least a ¾-inch margin on both sides of a manuscript.

Depending on the size of the manuscript, the top and bottom margins may vary in size. In other words, if you want to "stretch" the manuscript, use wider margins at the top and bottom.

17. Draw pencil lines with the ruler and carefully trim the manuscript with scissors along these lines to its final size.

17
Final Practice Exercises, Reference Folders, and Framing

Materials

Draftsman's pencil and sharpener
Soft eraser
Ruler
Adhezo-tack
Scissors
Calligraphic pen holder and nibs
Round pen holder and drawing pen
Pen cleaner
Black India ink
Colored drawing ink (various colors)
Paintbrush
Enamel paint (various colors)
Paint remover
Mottled Parchain paper
Eberhard Faber Stenorace No. 1507 eraser
Pencil sharpener
Black poster board

By now you are sufficiently skilled to prepare a manuscript that is good enough to be given to someone who would appreciate both the wisdom of the text and the artistry of the calligrapher.

Practice Exercise 1

Study the seven illustrations of the sentence, *There is no one perfect frame because there are many ways in which to tastefully frame calligraphy*. These layouts for a short text may be used for much longer texts as well.

1. Choose a short text (a philosophical thought, passage from the Bible, or something else of this sort).

2. Decide which of the seven illustrated layouts is best suited to your text.

3. Prepare the basic layout, skeleton, and final draft.

There is
 no one perfect frame
because there
 are many ways in
which to tastefully
 frame calligraphy.

❖ ∙ ❖ ∙ ❖ ∙ ❖ ∙ ❖

There is no one perfect frame
because there are many
ways in which to
tastefully frame
calligraphy.

There is
no one perfect frame
because there are many ways
in which to tastefully
frame calligraphy.

There is
no one
perfect frame
because
There are
many ways
in which to
tastefully
frame
Calligraphy.

There is ~ ❖ ~ ❖ ~
❖ no one perfect frame
because There ❖ ~ ❖
~ ❖ ~ are many ways
❖ in which to ~ ❖ ~ ❖
~ tastefully frame ~
❖ ~ ❖ ~ calligraphy.

There is
no one perfect
frame because
there are many

ways in which to
tastefully frame
calligraphy.

There is no one perfect frame because there are many ways in which to tastefully frame calligraphy.

Practice Exercise 2

Plates I to X feature manuscripts that I have prepared for various purposes. To give you an opportunity to apply your skill and imagination, make your own manuscript using one of these for the basic layout. (The measurement given in the description beneath each manuscript is its original size.)

Reference Folders

Reference folders are helpful to the calligrapher in providing a fund of ideas to draw from when faced with the challenge of a new manuscript.

Prepare three reference folders.

Folder No. 1—Completed manuscript folder

In this folder place examples of your best work. Make a photocopy of each manuscript before selling it or giving it away. On the photocopy indicate the colors used.

This folder will be helpful not only in giving you ideas for new manuscripts, but also in showing you the mistakes you have made.

Folder No. 2—Alphabet folder

In this folder place samples of your lettering in various styles. Each sheet of drawing paper should feature a complete alphabet. There should be sheets for the following:

- Flourished majuscules
- Formal Script
- Roman letters with and without serifs
- Illuminated letters in various colors
- Ornamental letters in various colors

Folder No. 3—Ornamental designs and line finishings folder

In this folder place your various ornamental designs and line finishings, drawn in assorted colors.

As time passes you will know what material should be added to (or withdrawn from) the folders.

Framing

Manuscript framing must be kept simple. Ornate framing distracts attention from the calligraphy. A black and gold frame with non-glare glass is best. Richly illuminated manuscripts are attractive with or without a mat. An experienced framer can show you different frames and various colored mats, and you will be able to choose the one most suitable for your manuscript.

When you make a gift of one of your manuscripts, getting it framed yourself is unnecessary. The recipient of a beautiful scroll is always delighted to buy a frame for it. Present your manuscript as it has been done since ancient times: Roll up the scroll carefully and tie it gently with a bow of colored velvet ribbon. A light blue ribbon for a boy's birth announcement is appropriate, a white ribbon is needed for a wedding announcement, and black is suitable for a memorial scroll.

Further Reading

Advanced Calligraphy, Katherine Jeffares (Wilshire Book Company).

Calligraphy, Katherine Jeffares (Wilshire Book Company).

Calligraphy in Ten Easy Lessons, Eleanor Winter and Laurie Lico (Thorsons Publishing Group).

Calligraphy Made Easy, Margaret Shepherd (Thorsons Publishing Group).

Calligraphy Projects for Pleasure and Profit, Margaret Shepherd (Thorsons Publishing Group).

Calligraphy Workbook, George L. Thomson (Thorsons Publishing Group).

Capitals for Calligraphy, Margaret Shepherd (Thorsons Publishing Group).

Getting Started in Calligraphy, Nancy Baron (Sterling Publishing Co.).

Learning Calligraphy, Margaret Shepherd (Thorsons Publishing Group).

Glossary

———◆———

Almost-touch: A closed formation of letters of Formal Script, each letter giving the appearance of almost touching the following letter. Such letters are also called "closed letters."

Ascenders: Letters with parts that rise above the waist line.

Base Line: The bottom line, on which most letters rest.

Book-Hand: Before the first printers copied Formal Script, it was called the "Book-Hand." Drawn in black and/or colors with Roman letters as majuscules, the Book-Hand gives a manuscript an elegant appearance.

Built-up Letters: Basic letters that have been thickened by additional strokes. When filled in with color, built-up letters become illuminated letters.

Calligraphic Nibs: Pens with an integral ink reservoir. A wide nib point is capable of producing fine or broad strokes depending on the movement of the hand.

Calligraphy: The art of fine writing.

Chancery Cursive: A form of flourished writing dating back to c. 1437, originally used by scribes of the Apostolic Chancery.

Counter System: A system of proper letter spacing.

Cursive: Written so that the characters are rapidly formed without lifting the pen from the paper.

Descenders: Letters with parts that extend below the base line.

Draftsman's Pencil: A special-purpose mechanical pencil having a slip-proof knurled grip.

Drawing Pen: A special-purpose pen used for drawing very fine lines.

Final Draft: A pencil version (completed skeleton) of the finished manuscript.

Flourish: Decoration of letters, usually by the addition of sweeping strokes.

Flourishment: Strokes added to the basic stroke which ornament or flourish a letter.

Formal Script: A heavy form of Chancery Cursive (and/or Formal Italic). Formal Script is frequently used for the minuscule letters that follow the initial letter, which is a Roman letter (with or without colors). Their use in this way contributes to the visual harmony of the completed manuscript.

Gild: To illuminate a manuscript with gold leaf, or with gold leaf and colors. (The use of gold paint for illumination is *not* gilding.)

Illuminate: To decorate the text of a manuscript (or a word or initial letter within the manuscript) with gold, silver, and colors.

Illuminated Letter: A letter filled in with one color.

Ink

 India ink: A special-purpose, heavy black permanent ink. The ingredients of India ink that bond the pigment to the paper and make the writing permanent are acidic and destructive to the delicate brass and brass alloy parts of pen nibs. India ink, therefore, may be used only with nibs designed for it.

 Waterproof or indelible ink: An ink, available in a wide variety of colors, that is not soluble in water, and is thus permanent. Waterproof ink is not as permanent as India ink, but is far more convenient to use. It may be used in the italic fountain pen, from which India ink would not flow and whose nib would be destroyed by India ink.

 Water-soluble ink: Ink that consists solely of pigment and water, and thus may be erased or removed by diluting it with water.

Italic: A form of writing that slants to the right, attributed to Aldus Manutius of Venice.

Italic Fountain Pen: A special-purpose pen, the nib of which produces both wide and fine lines. It is similar in function to a regular fountain pen except that various-size nibs may be readily installed.

Layout: The arrangement of the various components of a manuscript in order to achieve a harmonious appearance; the skeleton of a manuscript.

Lead Pointer: A special device that sharpens the lead in a draftsman's pencil.

Line Finishings: Small ornamental designs used to fill in "white" areas at the beginning or end of a line in a manuscript.

Majuscules: Capital letters.

Manuscript: (*manu:* hand; *script:* writing) A book or document in any kind of handwriting, as opposed to print.

Massed Black Text: Flourished (or basic) Formal Italic or Chancery Cursive in black ink.

Minuscules: All letters that are not capital letters; lower-case letters.

Ornamental Designs: Decorative drawings, sometimes in color, used to enhance the overall appearance of a manuscript. They may be very simple or quite elaborate.

Ornamental Letter: A letter larger than an illuminated letter, and filled in with more than one color and/or ornamental design.

Ornamentation: Anything used to embellish or beautify a letter, word, or manuscript.

Reference Lines: Pencil lines drawn down the center of and across the skeleton to aid in the layout of components of the manuscript.

Reference Marks: Cross marks drawn with a nylon tip pen near the top, at the center, and near the bottom of the vertical reference line of the skeleton. They are used with the vertical pencil line on the manuscript to insure alignment.

Rubrication: The addition of colored (originally only red) letters or ornamental designs to a black-lettered manuscript.

Scrivener: A professional penman, scribe, copyist, clerk, or secretary.

Scroll: Generally speaking, a document that has been prepared by a professional scribe. Usually, a scroll is rolled up when it is presented or stored.

Serifs: Small decorative strokes placed on open ends of basic letters.

Skeleton: A sheet of blank drafting paper used to determine the arrangement of the components of a manuscript.

Span: When drawing the text of a manuscript, the distance along a line that the calligrapher may traverse without moving the paper.

Versal: A word drawn with an illuminated first letter or paragraph initial (sometimes preceded by a small line finishing) and finished with Formal Script letters to set it off from the flourished italics of the body of the manuscript. Versals are sometimes used to indicate where paragraphs begin in a solid block of text in which each paragraph runs directly into the next.

Waist Line: A line that corresponds to the center of a letter, or to the top of a minuscule.